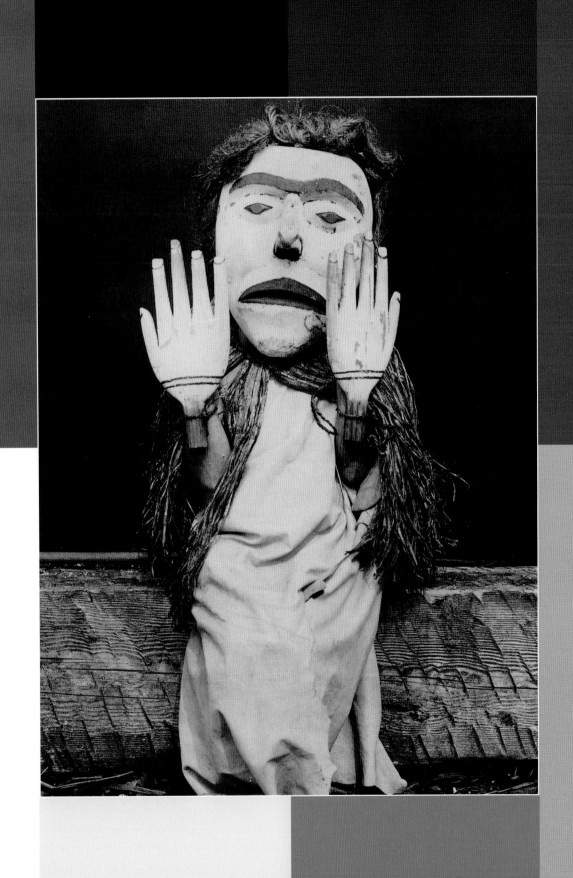

(Above) NUHLIMKILAKA, KOSKIMO

9 8 7 6 5 4 3 2 1
Digit on the right indicates the number of this printing
Library of Congress Cataloging-in-Publication Number 2002108449

ISBN 0-7624-1498-7

Dust jacket and interior design by Gwen Galeone
Edited by Joelle Herr
Typography: Garth Graphic, Lithos, and Cold Mountian

Native American photographs by Edward S. Curtis, Collection of the Library of Congress.
Edward S. Curtis self-portrait, back flap, and p. 6: Courtesy of Flury and Company, Seattle.

This book may be ordered by mail from the publisher.
But try your bookstore first!

Published by Courage Books, an imprint of
Running Press Book Publishers
125 South Twenty-second Street
Philadelphia, Pennsylvania 19103-4399

Visit us on the web!
www.runningpress.com

Songs of the Earth

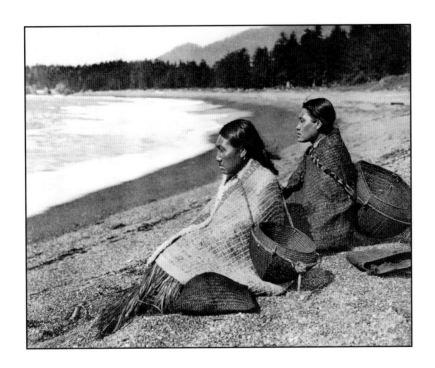

A Timeless Collection of Native American Wisdom

PHOTOGRAPHS BY EDWARD S. CURTIS

COURAGE
BOOKS
AN IMPRINT OF RUNNING PRESS
PHILADELPHIA • LONDON

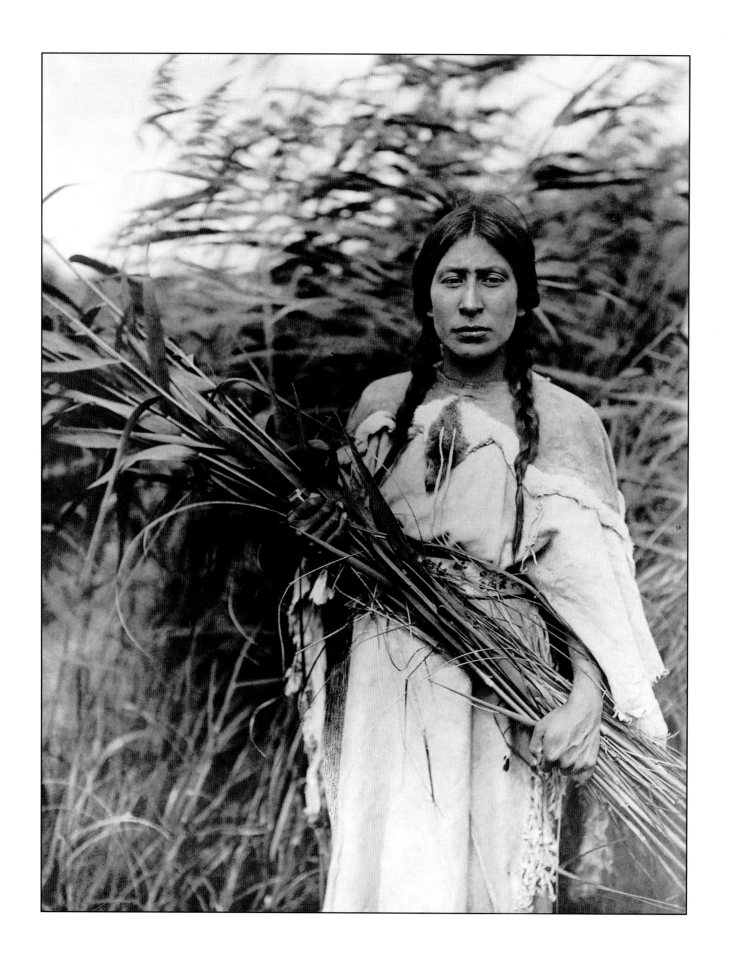

Contents

(Pictured Left) THE RUSH GATHERER

INTRODUCTION

BY 1868, WHEN EDWARD SHERRIFF CURTIS WAS BORN, THE CIVIL WAR HAD ENDED AND AMERICA'S ATTENTION HAD SHIFTED TO THE FINAL TAMING OF THE WEST. THE TRANSCONTINENTAL RAILROAD

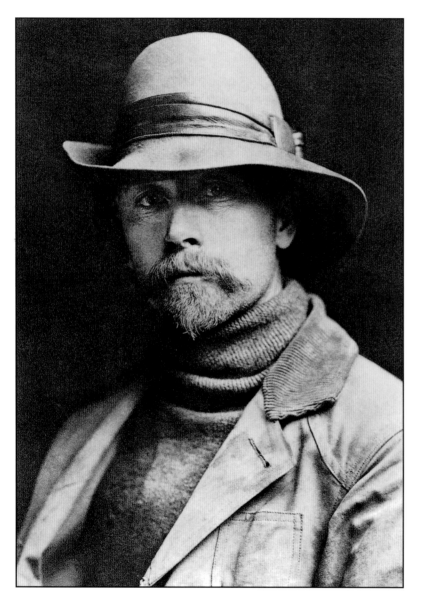

(Pictured Above) EDWARD S. CURTIS SELF-PORTRAIT

was nearing completion, and the remaining independent Native American tribes found themselves in deepening conflicts with the government. Many were forced to fight.

By the time Curtis and his family moved from Wisconsin to Seattle in 1891, all of America's native tribes had been forced to "accept" government terms and were either confined to reservations or being assimilated into white culture.

In Seattle, Curtis developed skill as a photographer and established his own studio. Intrigued by the native residents of the area, Curtis began photographing them. The commercial potential for such images was strong, and Curtis became convinced that he was witnessing an irreversible loss of Native American culture.

To help document that culture, Curtis began a series of journeys across the West to photograph members of various tribes. His ambitions expanded, and by 1904 an immense project was taking shape in his mind.

In 1907, he published the first volume of what would become his twenty-volume masterwork: *The North American Indian.* Each volume of this work focused on a specific tribe or group of tribes, and was published in a limited edition of 500 copies.

Curtis's energy and perseverance during the course of his immense project were nothing short of amazing. His journeys

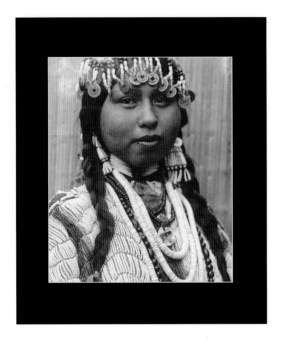 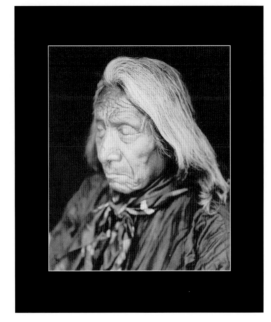 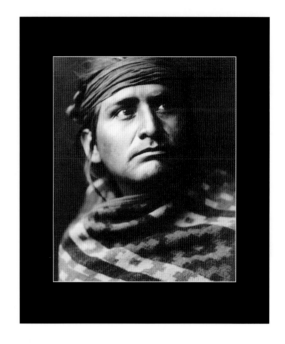

encompassed thousands of miles, often under daunting conditions. With the help of assistants and interpreters, he filled *The North American Indian* with tribal histories, folk stories, vocabularies, religious rites, and songs.

Curtis attempted to meet his subjects on their own terms, taking part in their daily and ceremonial lives whenever he could. He was even initiated as a Snake Priest in the Hopi Snake Cult ceremony.

Despite his hopes, it was impossible for Curtis to capture images of Native American life as it had once existed. Many of his portraits were created under studio conditions, and he often romanticized Indians according to the convention of the time. What Curtis did have was the cooperation and blessing of subjects who had often lived traditional tribal life, people who understood and wished to see recorded the unique facets of their cultures.

This book presents some of Curtis's most striking photographs. Accompanying them are statements of cultural values, beliefs, and attitudes from a number of Native Americans who lived and experienced traditional tribal life in the years between the Civil War and 1930, the year Curtis finished *The North American Indian*.

THEIR WORDS PRESERVE THE WISDOM, AND THE PHOTOGRAPHS GIVE INDIVIDUAL FACES TO HISTORY.

from father to son

RELIGION, TRADITION, AND BEING

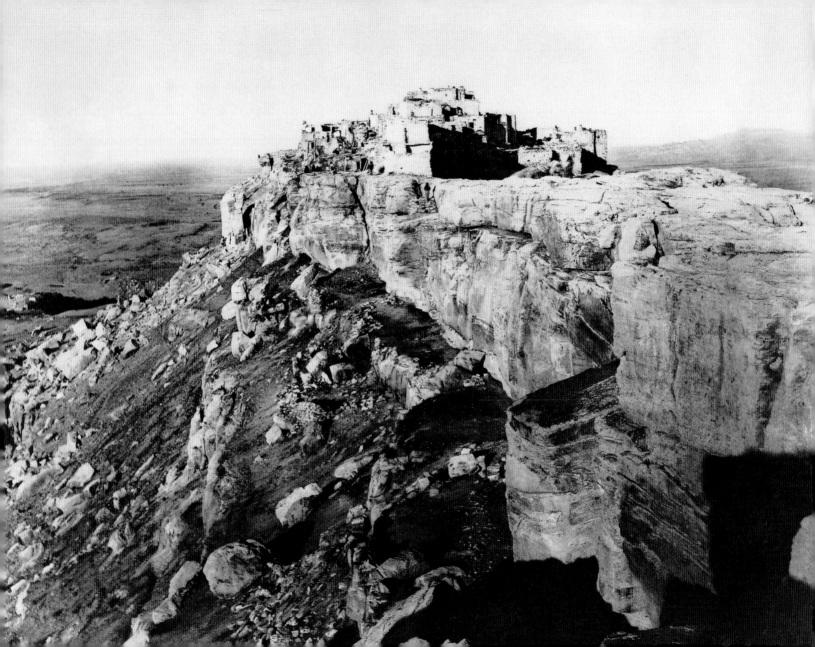

The American Indian

is of the soil, whether it be the region of forests, plains, pueblos,

or mesas. He fits into the landscape, for the hand that fashioned

the continent also fashioned the man for his surroundings.

◆

—LUTHER STANDING BEAR

(1868?–1939) Oglala Sioux chief

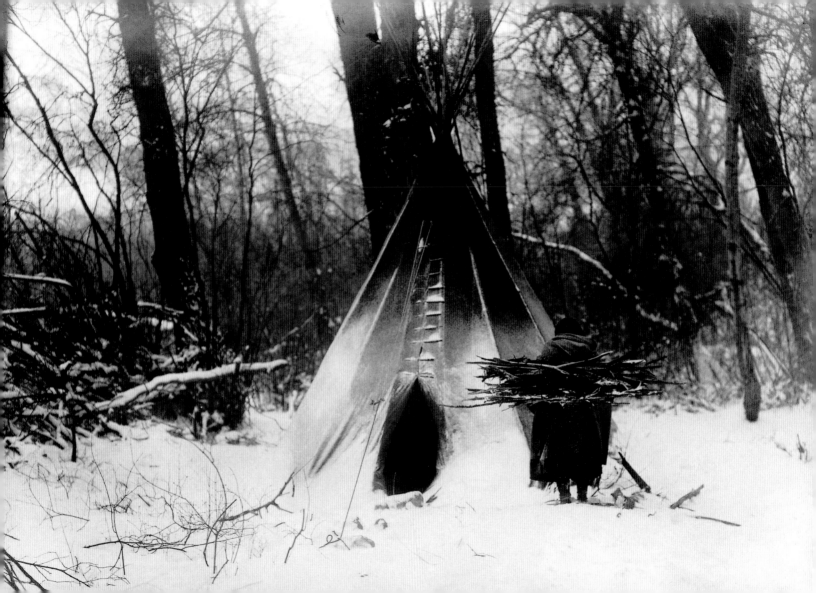

YOU HAVE NOTICED THAT EVERYTHING AN INDIAN DOES IS IN A CIRCLE, AND THAT IS BECAUSE

THE POWER OF THE WORLD ALWAYS WORKS IN
CIRCLES,

AND EVERYTHING TRIES TO BE ROUND. . . . THE SKY IS ROUND, AND I HAVE HEARD THAT THE

EARTH IS ROUND LIKE A BALL, AND SO ARE ALL THE STARS. THE WIND, IN ITS GREATEST POWER,

WHIRLS. BIRDS MAKE THEIR NESTS IN CIRCLES, FOR THEIRS IS THE SAME RELIGION AS OURS. . . .

EVEN THE SEASONS FORM A GREAT CIRCLE IN THEIR CHANGING, AND ALWAYS COME BACK AGAIN

TO WHERE THEY WERE. THE LIFE OF A MAN IS A CIRCLE FROM CHILDHOOD TO CHILDHOOD, AND

SO IT IS IN EVERYTHING WHERE POWER MOVES.

—BLACK ELK

(1863–1950) Oglala Sioux holy man

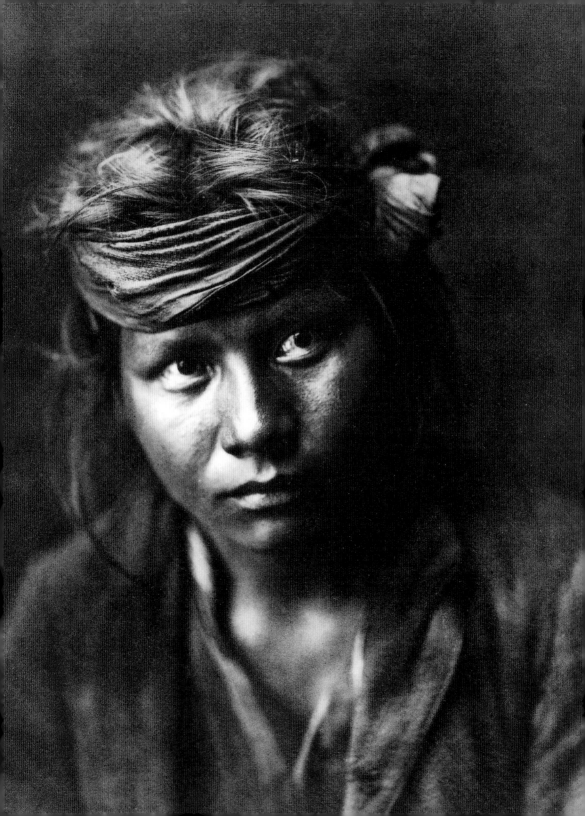

We were taught to believe

that the Great Spirit sees and hears everything,

and that he never forgets;

that hereafter he will give every man

a spirit-home according to his deserts . . .

This I believe, and all my people believe the same.

—JOSEPH [HINMATON YALATKIT]

(1830–1904) Nez Percé chief

(Pictured Left) A SON OF THE DESERT, NAVAJO

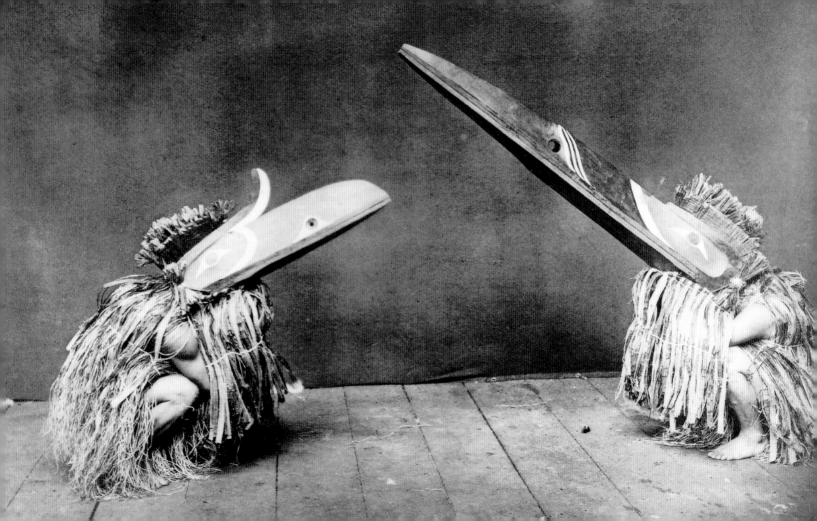

ALL THINGS IN THE WORLD ARE TWO. IN OUR MINDS WE ARE TWO—

GOOD AND EVIL.

WITH OUR EYES WE SEE TWO THINGS—THINGS THAT ARE FAIR AND THINGS THAT ARE UGLY. . . .

WE HAVE THE RIGHT HAND THAT STRIKES AND MAKES FOR EVIL, AND THE LEFT HAND FULL OF

KINDNESS, NEAR THE HEART. ONE FOOT MAY LEAD US TO AN EVIL WAY, THE OTHER FOOT MAY

LEAD US TO A GOOD. SO ARE ALL THINGS TWO, ALL TWO.

—EAGLE CHIEF [LETAKOTS-LESA]

(late 19th century) Pawnee

(Pictured Left) KOTSUIS AND HOHHUQ, NAKOAKTOK

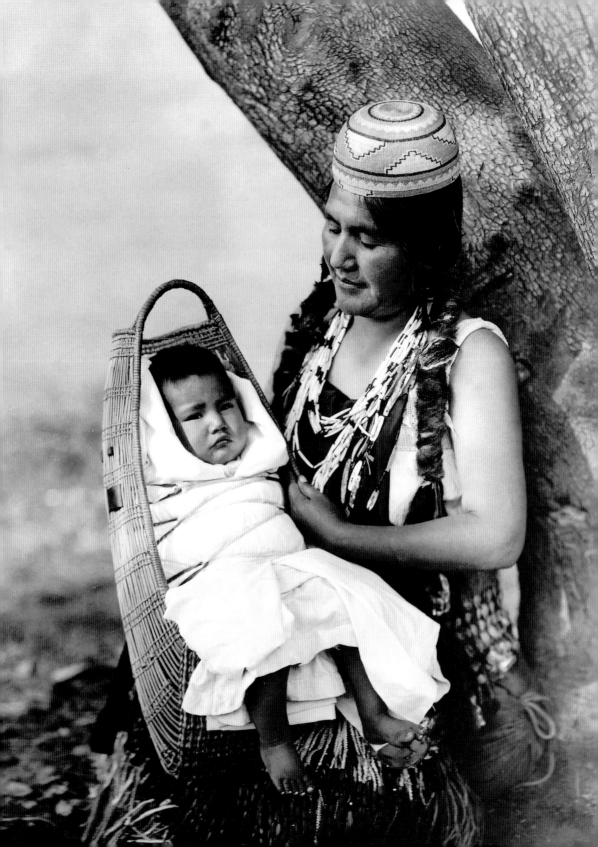

... I HOPE THE GREAT HEAVENLY
F A T H E R ,

WHO WILL LOOK DOWN UPON US, WILL GIVE ALL THE TRIBES HIS BLESSING, THAT WE MAY GO

FORTH IN PEACE, AND LIVE IN PEACE ALL OUR DAYS, AND THAT HE WILL LOOK DOWN UPON OUR

CHILDREN AND FINALLY LIFT US FAR ABOVE THIS EARTH; AND THAT OUR HEAVENLY FATHER

WILL LOOK UPON OUR CHILDREN AS HIS CHILDREN,

THAT ALL THE TRIBES MAY BE HIS CHILDREN, AND AS WE SHAKE HANDS TODAY UPON THIS

BROAD PLAIN, WE MAY FOREVER LIVE IN PEACE.

—RED CLOUD [MARPIYA-LUTA]
(late 19th century) Oglala Sioux chief

(Pictured Left) HUPA MOTHER AND CHILD

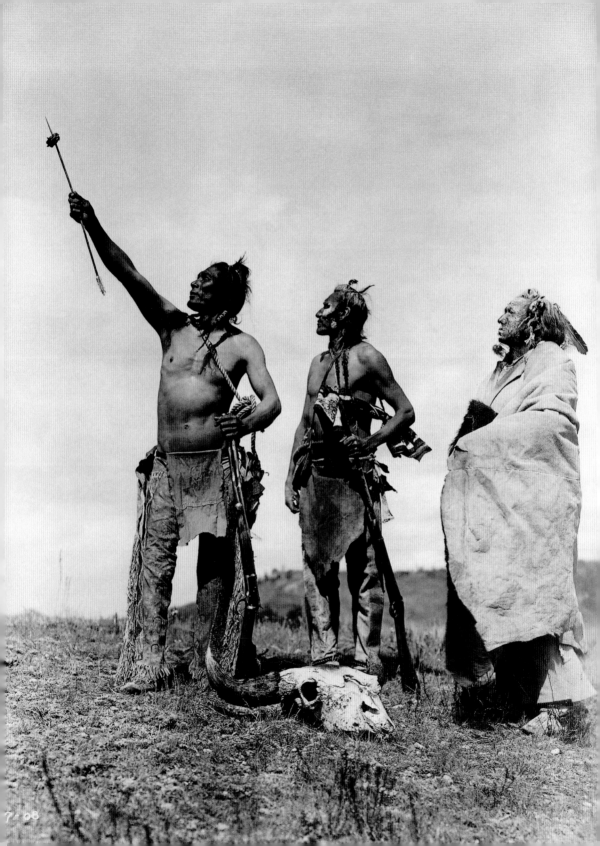

We had no churches,

NO RELIGIOUS ORGANIZATIONS,

NO SABBATH DAY, NO HOLIDAYS, AND

YET WE WORSHIPED.

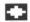

—GERONIMO [GOYATHLAY]

(1829–1909) Chiricahua Apache chief

(Pictured Left) THE OATH, APSAROKE

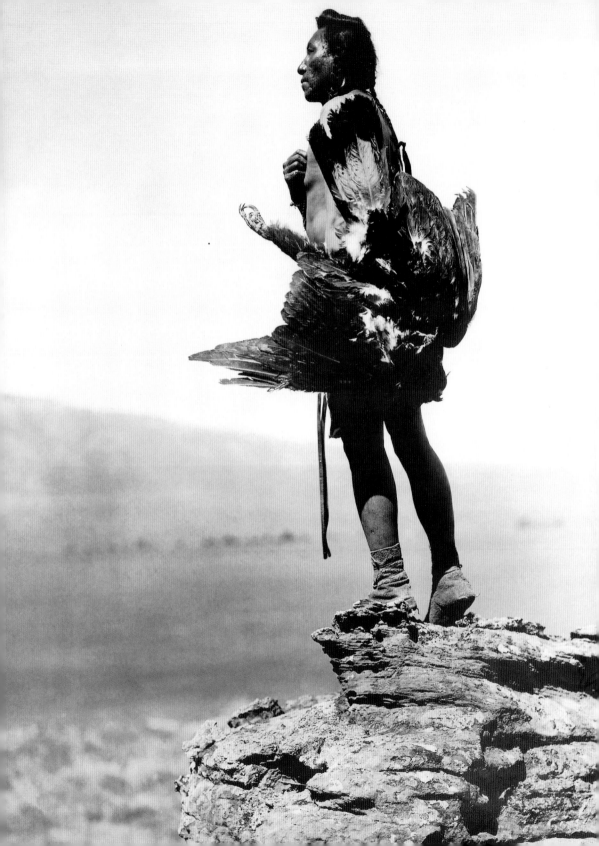

IN THE BEGINNING OF ALL THINGS, WISDOM AND

KNOWLEDGE WERE WITH THE ANIMALS, FOR TIRAWA, THE ONE ABOVE, DID NOT SPEAK DIRECTLY

TO MAN. HE SENT CERTAIN ANIMALS TO TELL MEN THAT HE SHOWED HIMSELF THROUGH THE

BEASTS, AND THAT FROM THEM, AND FROM THE STARS AND THE SUN AND THE MOON SHOULD

MAN LEARN. . . . ALL THINGS TELL OF TIRAWA.

—EAGLE CHIEF [LETAKOTS-LESA]
(late 19th century) Pawnee

(Pictured Left) THE EAGLE CATCHER

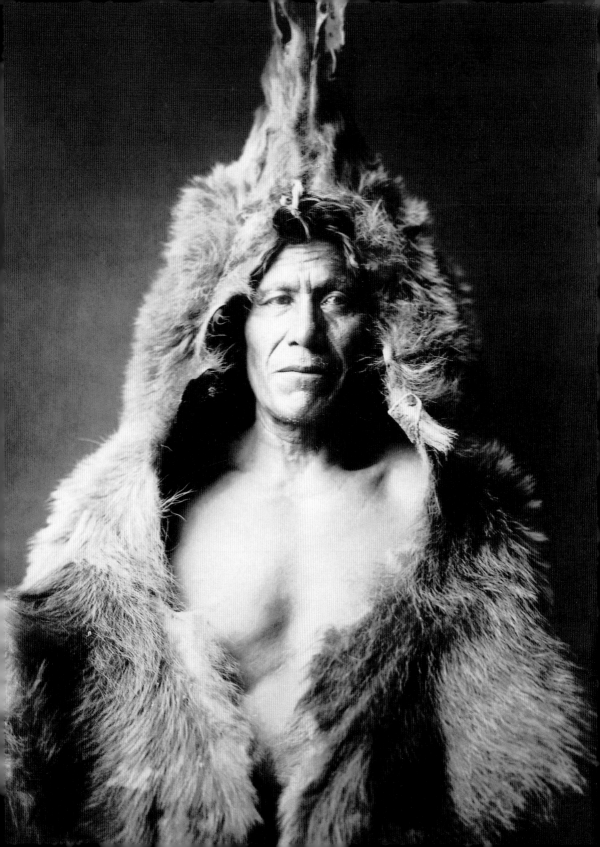

. . . everything on the earth has a purpose,

EVERY DISEASE AN HERB TO CURE IT,

AND EVERY PERSON A MISSION.

THIS IS THE INDIAN THEORY OF EXISTENCE.

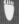

—MOURNING DOVE [CHRISTINE QUINTASKET]

(1888–1936) Salish

(Pictured Left) BEAR'S BELLY, ARIKARA

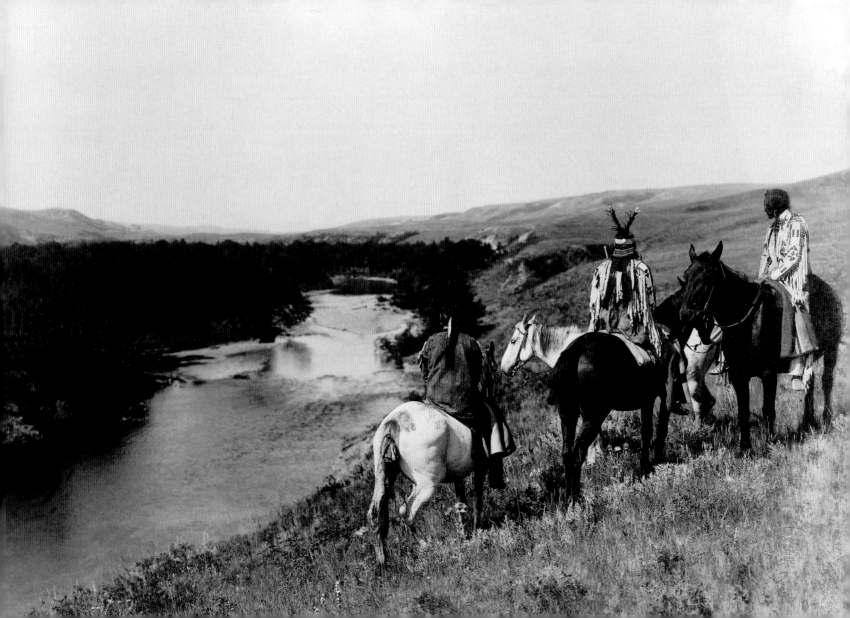

From Wakan-Tanka, the Great Mystery, comes all power. It is from Wakan-Tanka that the holy man has wisdom and the power to heal and to make holy charms. Man knows that all healing plants are given by Wakan-Tanka; therefore they are holy. So too is the buffalo holy, because it is the gift of Wakan-Tanka.

☀

—FLAT-IRON [MAZA BLASKA]
(late 19th century) Oglala Sioux chief

(Pictured Left) THE PIEGAN

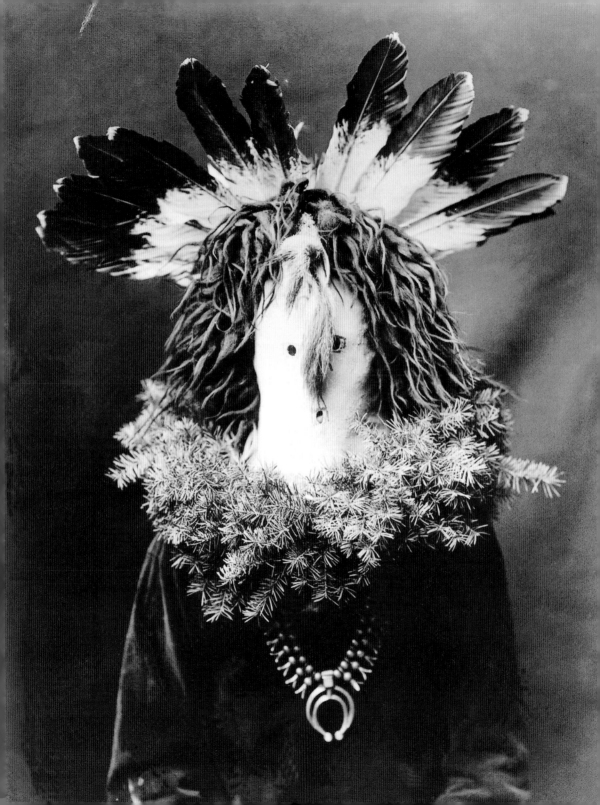

THE TRADITIONS OF OUR PEOPLE ARE HANDED DOWN FROM FATHER TO SON. THE CHIEF IS CONSIDERED TO BE THE MOST LEARNED, AND THE LEADER OF THE TRIBE. THE DOCTOR, HOWEVER, IS THOUGHT TO HAVE MORE INSPIRATION. HE IS SUPPOSED TO BE IN COMMUNION WITH SPIRITS. . . . HE CURES THE SICK BY THE LAYING ON OF HANDS, AND PRAYERS AND INCANTATIONS AND HEAVENLY SONGS. HE INFUSES NEW LIFE INTO THE PATIENT, AND PERFORMS MOST WONDERFUL FEATS OF SKILL IN HIS PRACTICE. . . . HE CLOTHES HIMSELF IN THE SKINS OF YOUNG, INNOCENT ANIMALS, SUCH AS THE FAWN; AND DECORATES HIMSELF WITH THE PLUMAGE OF HARMLESS BIRDS, SUCH AS THE DOVE AND HUMMING-BIRD. . . .

—SARAH WINNEMUCCA
(1844–1891) Paiute

(Pictured Left) HASCHOGAN, NAVAHO

The Great Spirit

is in all things; he is in the air we breathe.

The Great Spirit is our Father, but the earth is our mother.

She nourishes us; that which we put into

the ground she returns to us. . . .

—BIG THUNDER [BEDAGI]
(late 19th century) Wabanaki Algonquin

(Pictured Left) HASEN HARVEST, QAHATIKA

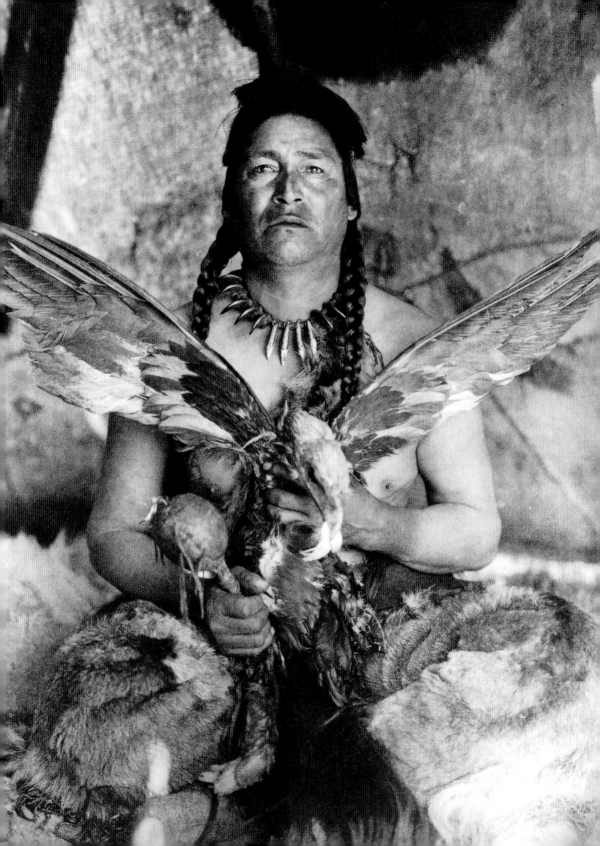

The life of an Indian is like the wings of the air. That is why you notice the hawk knows how to get his prey. The Indian is like that. The hawk swoops down on its prey; so does the Indian. In his lament he is like an animal. For instance, the coyote is sly; so is the Indian. The eagle is the same. That is why the Indian is always feathered up; he is a relative to the wings of the air.

▲

—BLACK ELK

(1863–1950) Oglala Sioux holy man

(Pictured Left) PLACATING THE SPIRIT OF A SLAIN EAGLE, ASSINIBOIN

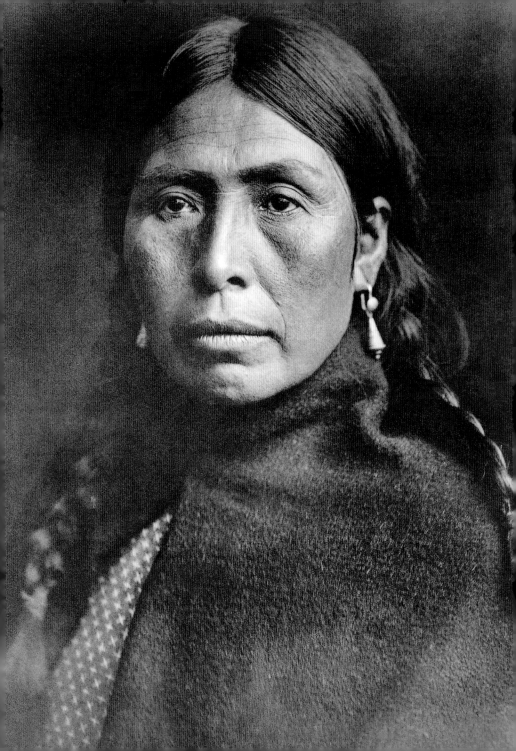

. . . I AM POOR AND NAKED, BUT I AM THE CHIEF
OF THE NATION. WE DO NOT WANT RICHES BUT
WE DO WANT TO TRAIN OUR CHILDREN RIGHT.
RICHES WOULD DO US NO GOOD. WE COULD NOT
TAKE THEM WITH US TO THE OTHER WORLD.

We do not want riches.
We want peace and love.

—RED CLOUD [MAKHPIYA-LUTA]

(late 19th century) Sioux chief

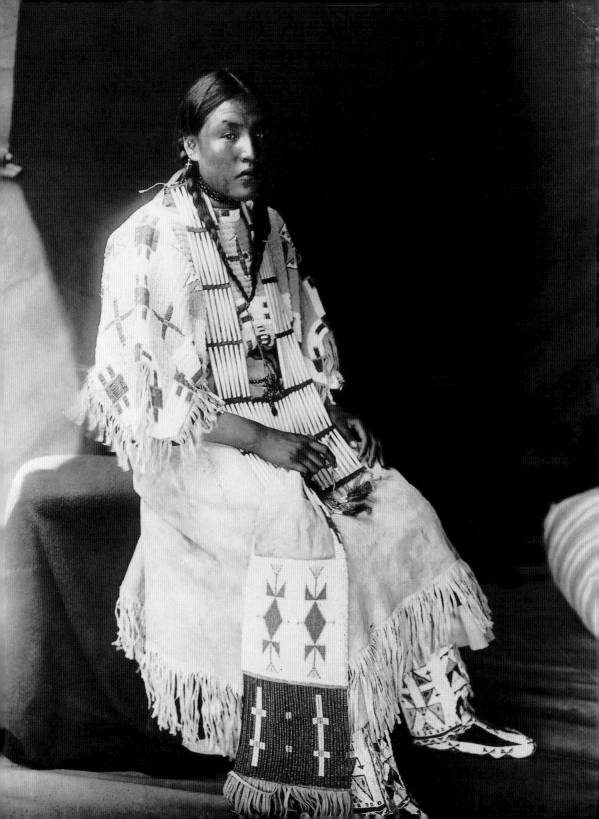

Out of the Indian approach to life

there came a great freedom—

an intense and absorbing love for nature;

a respect for life; enriching faith in a Supreme Power;

and principles of truth, honesty, generosity, equity, and

brotherhood as a guide to mundane relations.

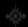

—LUTHER STANDING BEAR

(1868?–1939) Oglala Sioux chief

O ye people,

be ye healed; Life anew I bring unto ye.
O ye people, be ye healed;
Life anew I bring unto ye.
Through the Father over all Do I thus.
Life anew I bring unto ye.

—GOOD EAGLE [WANBLI-WASTE]
(late 19th century) Dakota Sioux holy man

one sky above us

UNITY, INDIVIDUALITY, AND CUSTOM

. . . I HAVE SEEN THAT IN ANY
GREAT UNDERTAKING
IT IS NOT ENOUGH FOR A MAN
TO DEPEND SIMPLY UPON HIMSELF.

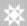

—LONE MAN [ISNA LA-WICA]

(late 19th century) Teton Sioux

(Pictured Left) DANCING TO RESTORE AN ECLIPSED MOON, QAGYUHL

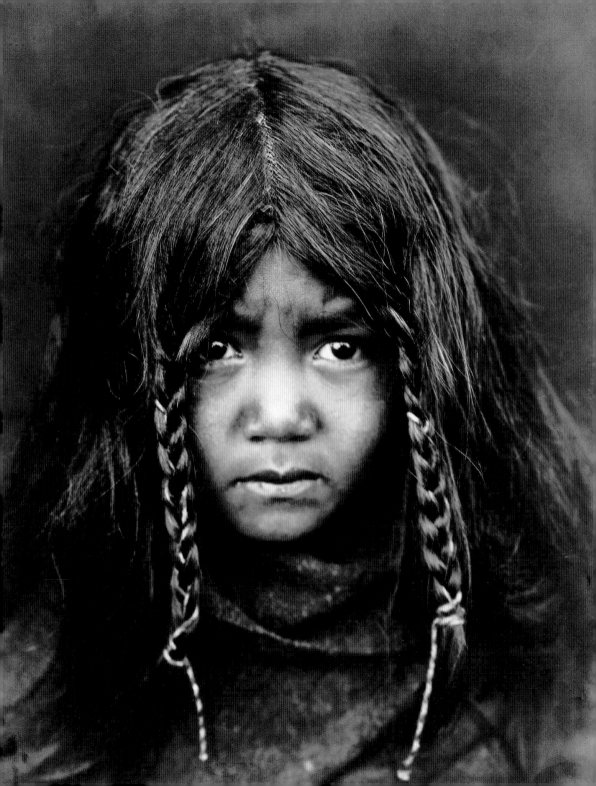

All birds, even those of the same species, are not alike, and it is the same with animals and with human beings. The reason Wakantanka does not make two birds, or animals, or human beings exactly alike is because each is placed here by Wakantanka to be an independent individuality and to rely upon itself.

—SHOOTER

(late 19th century) Teton Sioux

(Pictured Left) QUILCENE BOY

AMONG THE INDIANS

THERE HAVE BEEN NO WRITTEN LAWS.

CUSTOMS HANDED DOWN FROM GENERATION TO GENERATION HAVE BEEN THE ONLY LAWS TO GUIDE THEM. EVERY ONE MIGHT ACT DIFFERENT FROM WHAT WAS CONSIDERED RIGHT DID HE CHOOSE TO DO SO, BUT SUCH ACTS WOULD BRING UPON HIM THE CENSURE OF THE NATION. . . . THIS FEAR OF THE NATION'S CENSURE ACTED AS A MIGHTY BAND, BINDING ALL IN ONE SOCIAL, HONORABLE COMPACT.

—GEORGE COPWAY [KAH-GE-GA-GAH-BOWH]

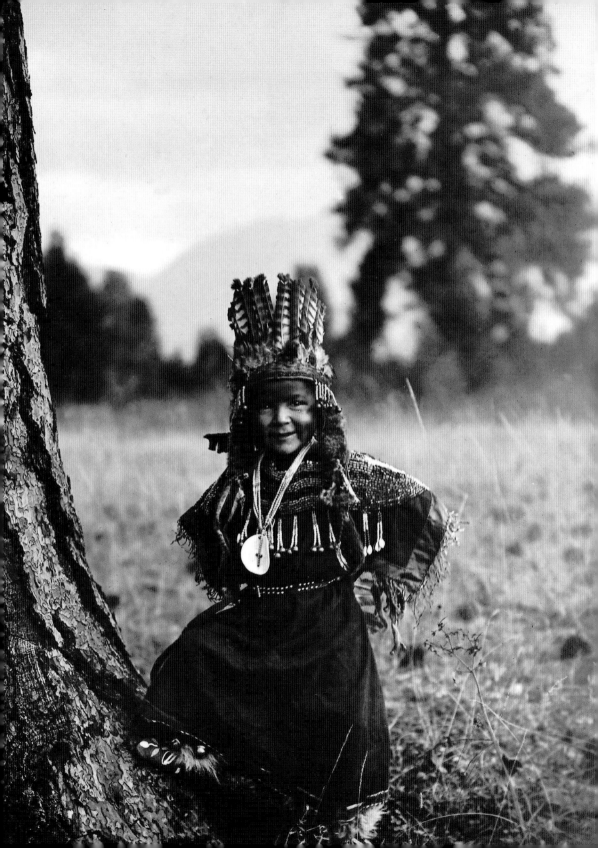

CHILDREN WERE ENCOURAGED TO DEVELOP STRICT DISCIPLINE

AND A HIGH REGARD FOR SHARING. WHEN A GIRL PICKED HER FIRST BERRIES AND DUG HER

FIRST ROOTS, THEY WERE GIVEN AWAY TO AN ELDER SO SHE WOULD SHARE HER FUTURE SUCCESS.

WHEN A CHILD CARRIED WATER FOR THE HOME, AN ELDER WOULD GIVE COMPLIMENTS,

PRETENDING TO TASTE MEAT IN WATER CARRIED BY A BOY OR BERRIES IN THAT OF A GIRL. THE

CHILD WAS ENCOURAGED NOT TO BE LAZY AND TO GROW STRAIGHT LIKE A SAPLING.

—MOURNING DOVE [CHRISTINE QUINTASKET]
(1888–1936) Salish

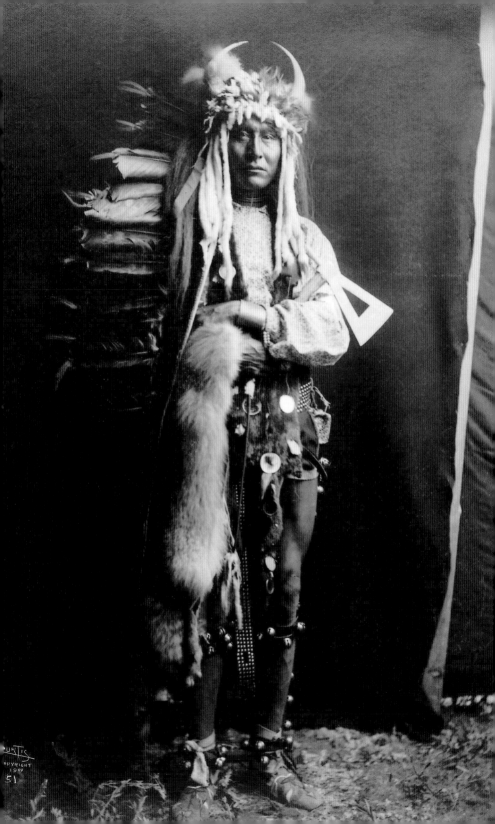

CONVERSATION
WAS NEVER BEGUN AT ONCE,

NOR IN A HURRIED MANNER. NO ONE WAS QUICK WITH A QUESTION, NO MATTER HOW IMPOR-

TANT, AND NO ONE WAS PRESSED FOR AN ANSWER. A PAUSE GIVING TIME FOR THOUGHT WAS

THE TRULY COURTEOUS WAY OF BEGINNING AND CONDUCTING A CONVERSATION. SILENCE WAS

MEANINGFUL WITH THE LAKOTA, AND HIS GRANTING A SPACE OF SILENCE TO THE SPEECH-MAKER

AND HIS OWN MOMENT OF SILENCE BEFORE TALKING WAS DONE IN THE PRACTICE OF TRUE

POLITENESS AND REGARD FOR THE RULE THAT, "THOUGHT COMES BEFORE SPEECH."

—LUTHER STANDING BEAR
(1868?–1939) Oglala Sioux chief

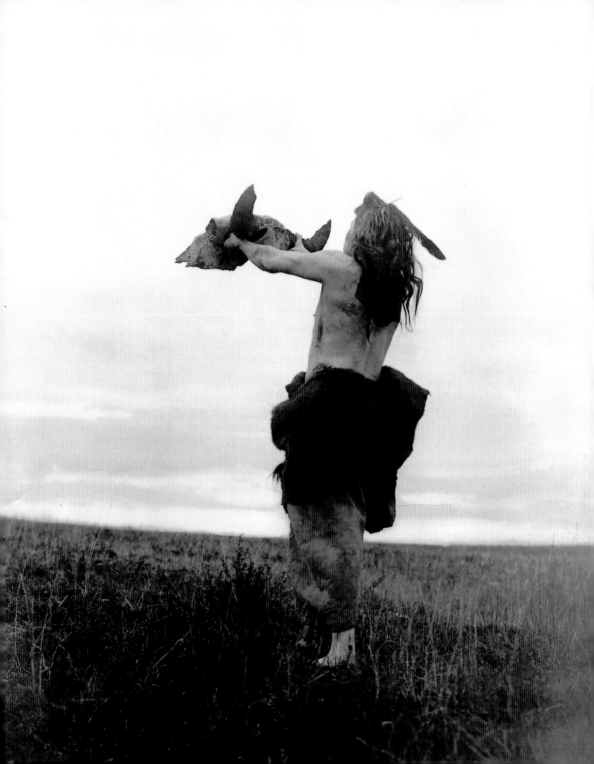

To "make medicine" is to engage upon a special period of fasting, thanksgiving, prayer and self-denial, even of self-torture. The procedure is entirely a devotional exercise. The purpose is to subdue the passions of the flesh and to improve the spiritual self. The bodily abstinence and the mental concentration upon lofty thoughts cleanses both the body and the soul and puts them into or keeps them in health. Then the individual mind gets closer toward conformity with the mind of the Great Medicine above us.

⚊

—WOODEN LEG
(late 19th century) Cheyenne

(Pictured Left) OFFERING THE BUFFALO SKULL, MANDAN

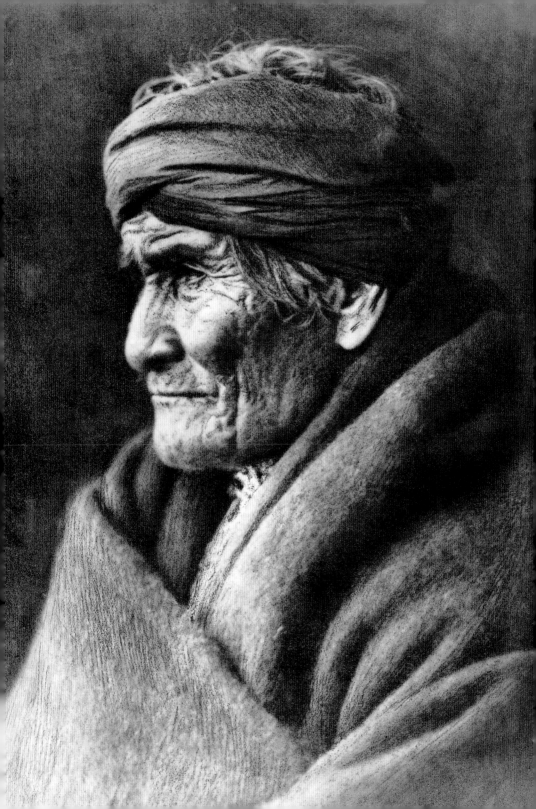

When a child my mother taught me the legends of our people; taught me of the sun and sky, the moon and stars, the clouds and storms. She also taught me to kneel and pray to Usen for strength, health, wisdom, and protection. We never prayed against any person, but if we had aught against any individual we ourselves took vengeance. We were taught that Usen does not care for the petty quarrels of men.

—GERONIMO [GOYATHLAY]

(1829-1909) Chiricahua Apache chief

(Pictured Left) GERONIMO, APACHE

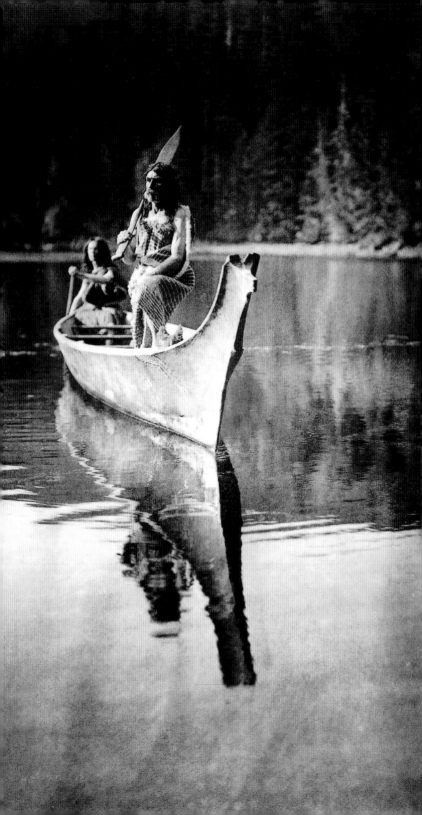

We are black, yet if we cut ourselves,

the blood will be red—and so with the whites it is the same,

though their skin be white. . . . I am of another nation,

when I speak you do not understand me. When you speak,

I do not understand you.

—SPOKAN GARRY

(1811–1892) Middle Spokane chief

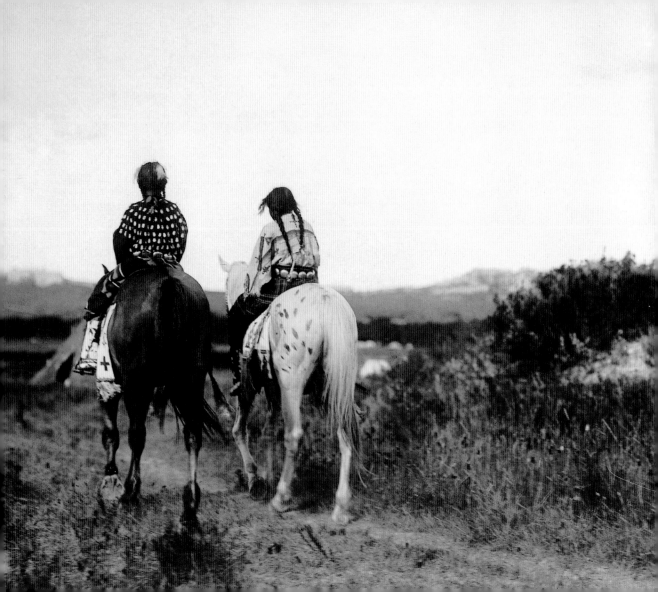

IN THE SKIN OF OUR FINGERS
WE CAN SEE THE TRAIL OF THE WIND;
IT SHOWS US WHERE THE WIND
BLEW WHEN OUR ANCESTORS
WERE CREATED.

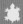

—NAVAJO LEGEND

(Pictured Left) DAUGHTERS OF A CHIEF

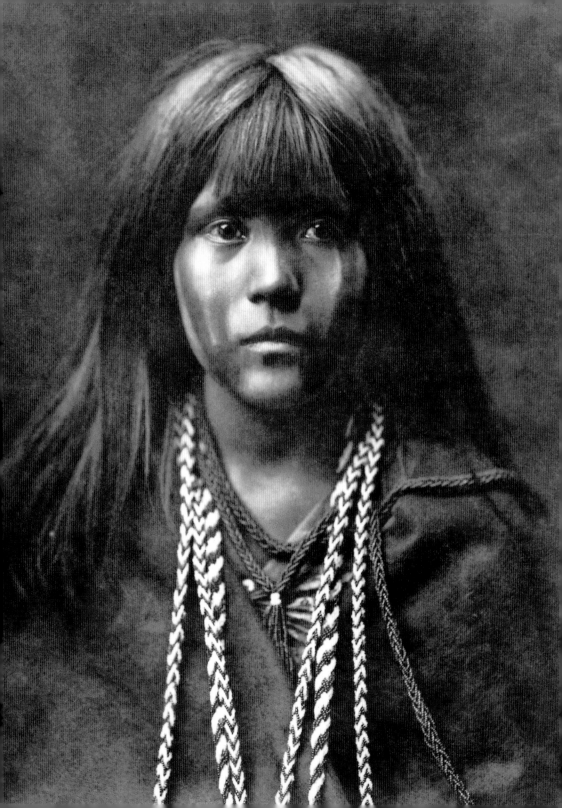

WHATEVER BEFALLS THE EARTH BEFALLS
THE SONS AND DAUGHTERS OF THE EARTH.
WE DID NOT WEAVE THE WEB OF LIFE;
WE ARE MERELY A STRAND IN IT.

Whatever we do to the web, we do to ourselves. . . .

—SEATTLE [SEATLH]

(1786–1866) Suquamish chief

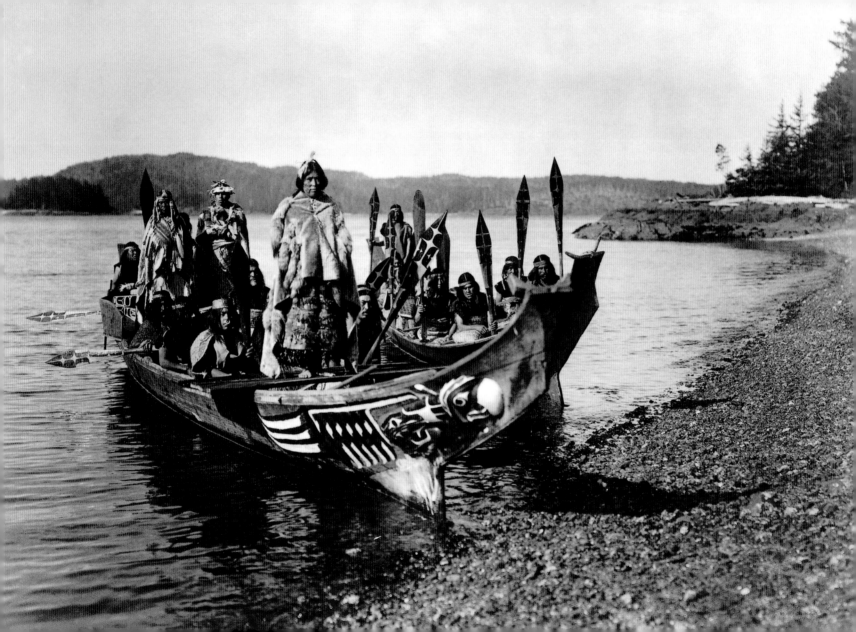

FOR AN IMPORTANT MARRIAGE THE CHIEF PRESIDED, AIDED BY HIS WIFE. HE PASSED A PIPE AROUND THE ROOM SO EACH COULD SHARE A SMOKE IN COMMON. IN THIS WAY FAMILIES WERE PUBLICLY UNITED TO BANISH ANY PAST OR FUTURE DISAGREEMENTS AND THUS STOOD AS "ONE UNITED." THE CHIEF THEN GAVE THE COUPLE AN ORATION OF HIS ADVICE, POINTING OUT THE GOOD CHARACTERISTICS OF EACH, AND THEN OFFERED HIS CONGRATULATIONS TO THEM FOR A HAPPY FUTURE.

—MOURNING DOVE [CHRISTINE QUINTASKET]
(1888–1936) Salish

(Pictured Left) THE WEDDING PARTY, QAGYUHL

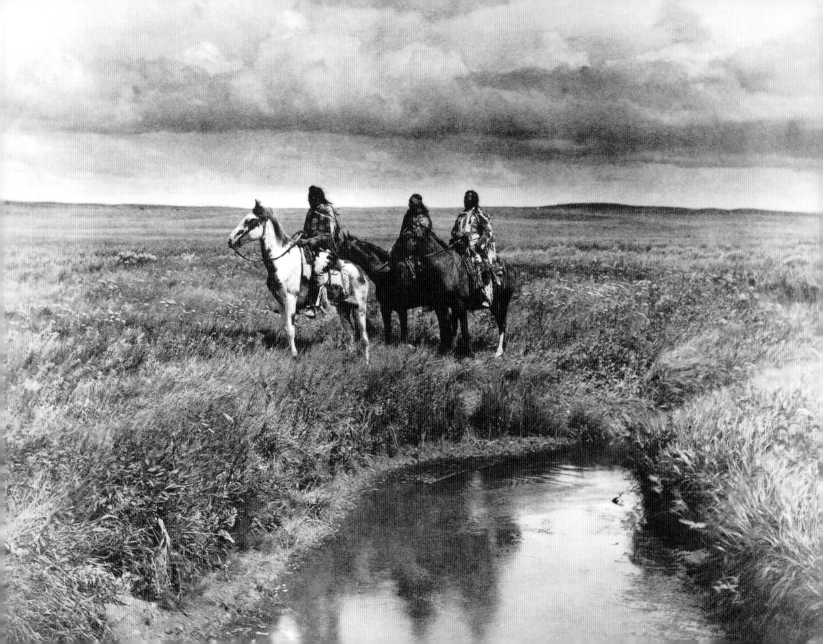

Whenever the white man

treats the Indian as they treat each other,
then we will have no more wars. We
shall all be alike—brothers of one father
and one mother, with one sky above
us and one country around us,
and one government for all.

❋

—JOSEPH [HINMATON YALATKIT]

(1830–1904) Nez Percé chief

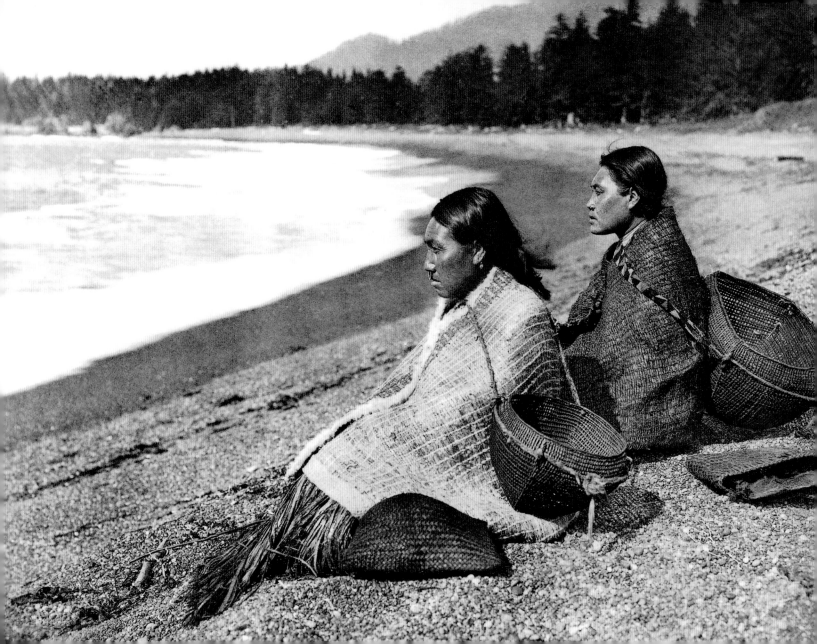

THE SOUND IS FADING AWAY
IT IS OF FIVE SOUNDS
FREEDOM
THE SOUND IS FADING AWAY
IT IS OF FIVE SOUNDS

—CHIPPEWA SONG

(Pictured Left) ON THE SHORES AT NOOTKA

the sweet breathing
of flowers

EARTH, NATURE, AND REVERENCE

Give me

the strength to walk the soft earth,
a relative to all that is! Give me the eyes
to see and the strength to understand,
that I may be like you. With your power
only can I face the winds.

—BLACK ELK

(1863–1950) Oglala Sioux holy man

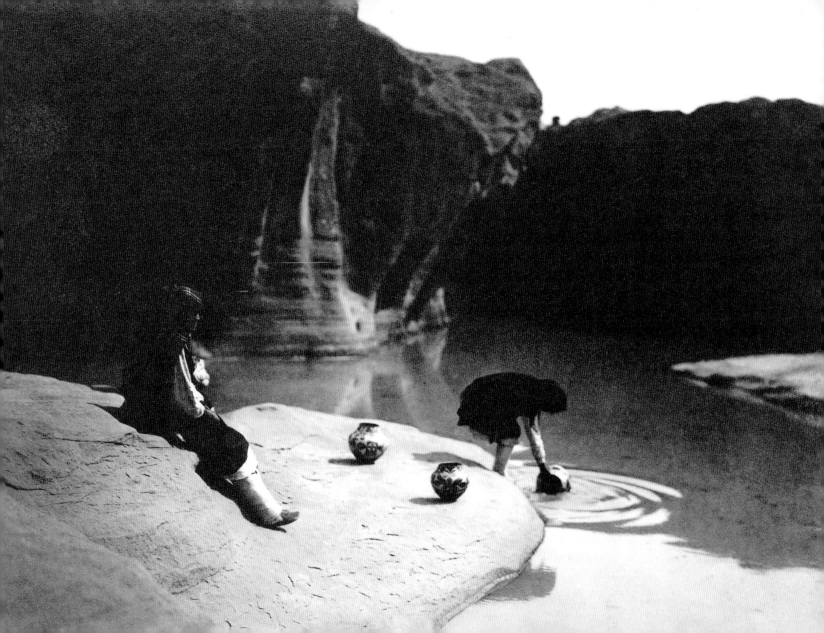

. . . FROM THE STARS
AND THE SUN AND THE MOON
SHOULD MAN LEARN.

—EAGLE CHIEF [LETAKOTS-LESA]

(late 19th century) Pawnee

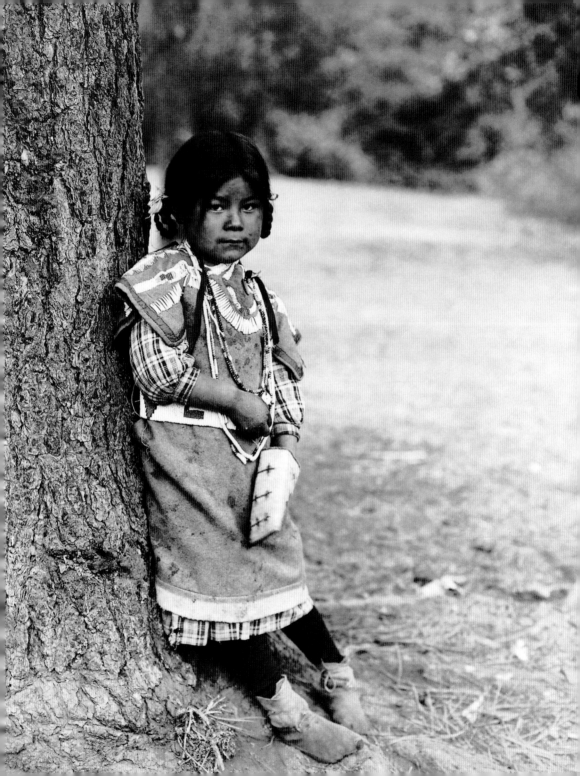

THE OUTLINE OF THE STONE IS ROUND, HAVING NO END AND NO BEGINNING; LIKE THE POWER OF THE STONE IT IS ENDLESS. THE STONE IS PERFECT OF ITS KIND AND IS THE WORK OF NATURE, NO ARTIFICIAL MEANS BEING USED IN SHAPING IT. OUTWARDLY IT IS NOT BEAUTIFUL, BUT ITS STRUCTURE IS SOLID, LIKE A SOLID HOUSE IN WHICH ONE MAY SAFELY DWELL.

—CHASED-BY-BEARS
(1843–1915) Santee-Yanktonai Sioux

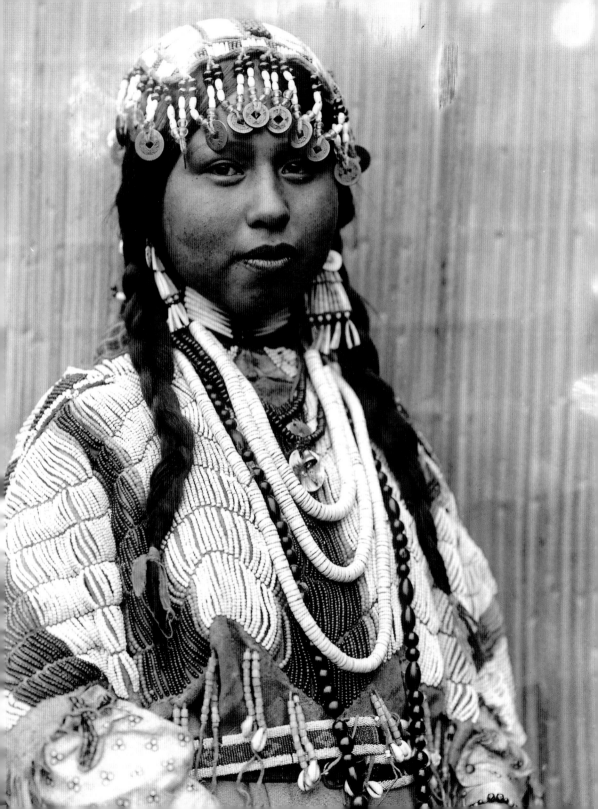

IN BEAUTY, I WALK

TO THE DIRECTION OF THE RISING SUN

IN BEAUTY, I WALK

TO THE DIRECTION TRAVELING WITH THE SUN

IN BEAUTY, I WALK

TO THE DIRECTION OF THE SETTING SUN

IN BEAUTY, I WALK...

ALL AROUND ME MY LAND IS BEAUTY

IN BEAUTY, I WALK

—NAVAJO [YEBECHI]

chant

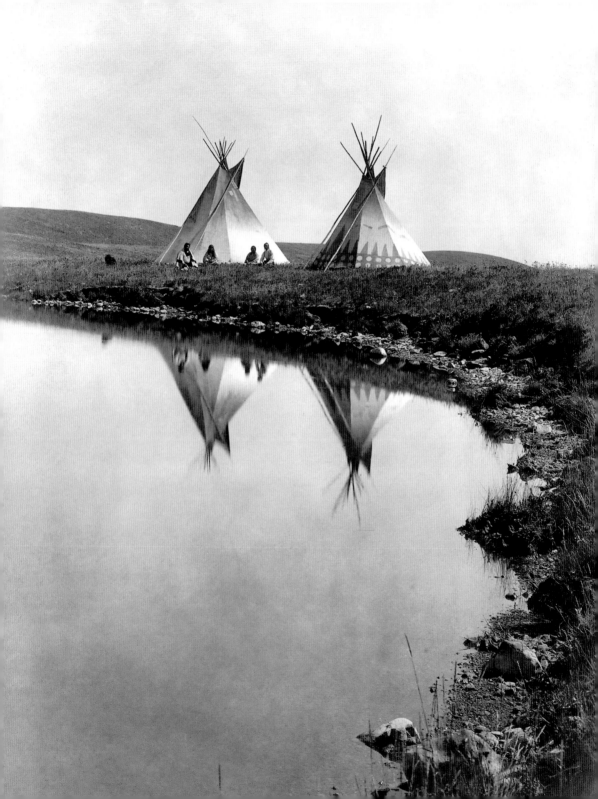

The soil you see is not ordinary soil—
it is the dust of the blood, the flesh, and bones of our ancestors. . . .
You will have to dig down through the surface before you
can find nature's earth, as the upper portion is Crow. The land,
as it is, is my blood and my dead; it is consecrated. . . .

—SHES-HIS
(late 19th century) Reno Crow

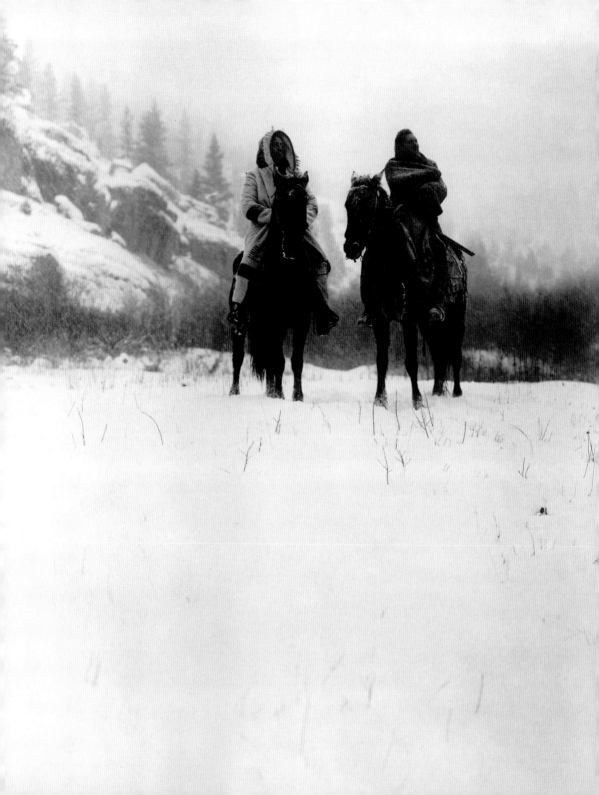

I HAVE NOTICED IN MY LIFE THAT ALL MEN HAVE A LIKING FOR SOME SPECIAL ANIMAL, TREE, PLANT, OR SPOT OF EARTH. IF MEN WOULD PAY MORE ATTENTION TO THESE PREFERENCES AND

SEEK WHAT IS BEST TO DO

IN ORDER TO MAKE THEMSELVES WORTHY OF THAT TOWARD WHICH THEY ARE SO ATTRACTED, THEY MIGHT HAVE DREAMS WHICH WOULD PURIFY THEIR LIVES. LET A MAN DECIDE UPON HIS FAVORITE ANIMAL AND MAKE A STUDY OF IT, LEARNING ITS INNOCENT WAYS. LET HIM LEARN TO UNDERSTAND ITS SOUNDS AND MOTIONS. THE ANIMALS WANT TO COMMUNICATE WITH MAN, BUT WAKANTANKA DOES NOT INTEND THEY SHALL DO SO DIRECTLY—MAN MUST DO THE GREATER PART IN SECURING AN UNDERSTANDING.

—BRAVE BUFFALO

(late 19th century) Teton Sioux medicine man

(Pictured Left) FOR A WINTER CAMPAIGN, APSAROKE

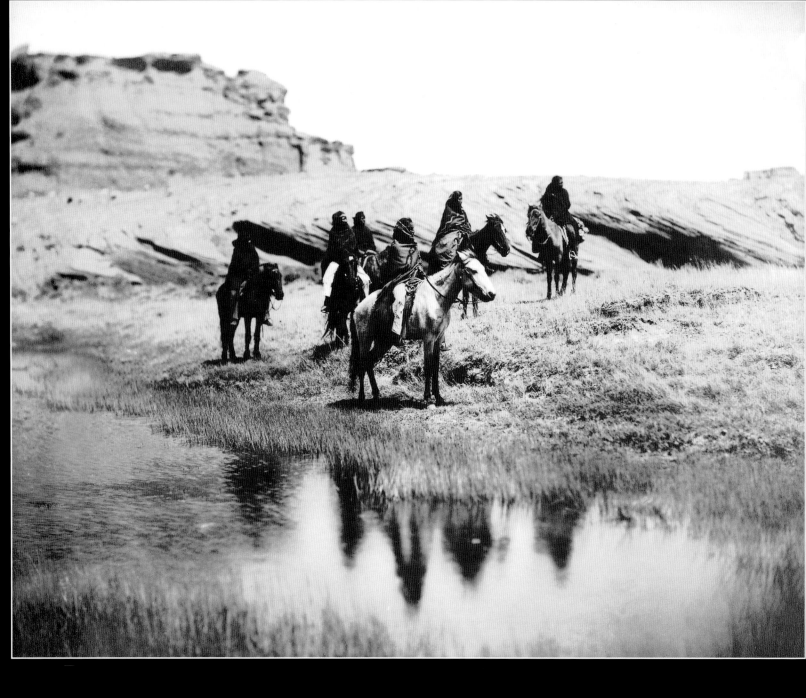

When I

was somewhat past ten years of age,

my father took me with him to watch the

horses out on the prairie. We watered the herd

and about the middle of the day came home

for dinner. . . . While we sat watching the

herd my father said: "These horses are

godlike, or mystery beings."

—WOLF CHIEF

(late 19th century) Hidatsa Sioux

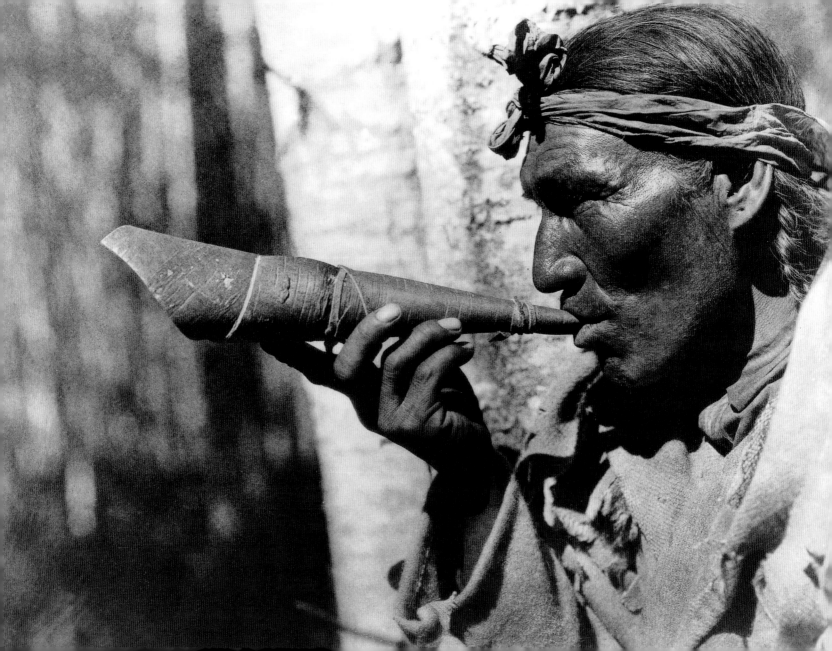

When we go hunting,

IT IS NOT OUR ARROW THAT KILLS THE
MOOSE, HOWEVER POWERFUL BE THE BOW;
IT IS NATURE THAT KILLS HIM.

—BIG THUNDER [BEDAGI]
(late 19th century) Webanaki Algonquin

(Pictured Left) MOOSE HUNTER, CREE

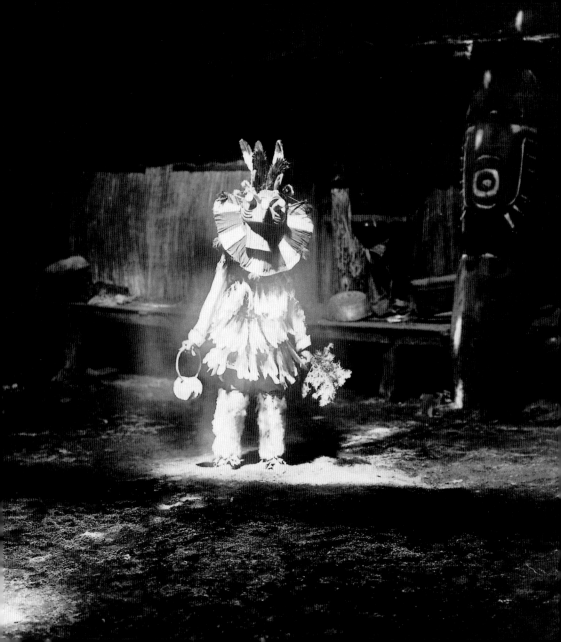

The old Indian teaching was that it is wrong to tear loose from its place on the earth anything that may be growing there. It may be cut off, but it should not be uprooted. The trees and the grass have spirits. Whatever one of such growths may be destroyed by some good Indian, his act is done in sadness and with a prayer for forgiveness because of his necessities. . . .

—WOODEN LEG

(late 19th century) Cheyenne

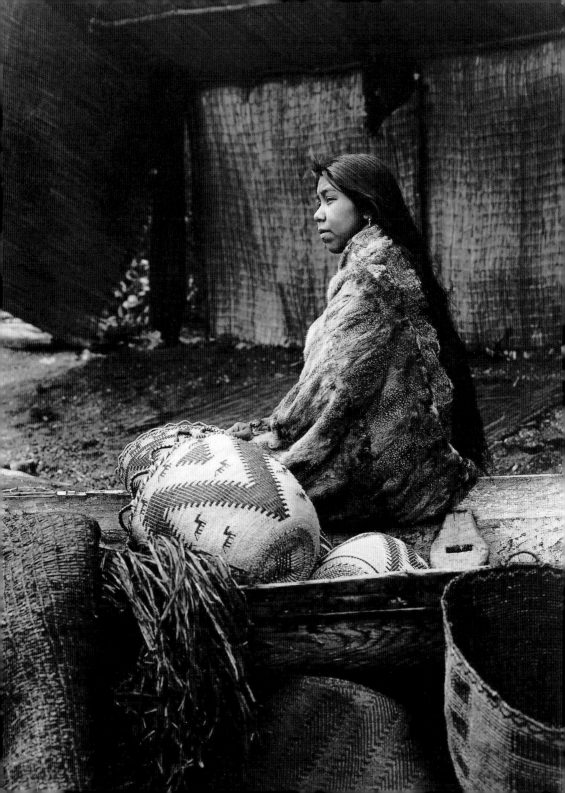

Yellow
butterflies
Over the blossoming, virgin corn,
With pollen spotted faces
Chase one another in
brilliant throng.

—HOPI SONG

(Pictured Left) CHIEF'S DAUGHTER, SKOKOMISH

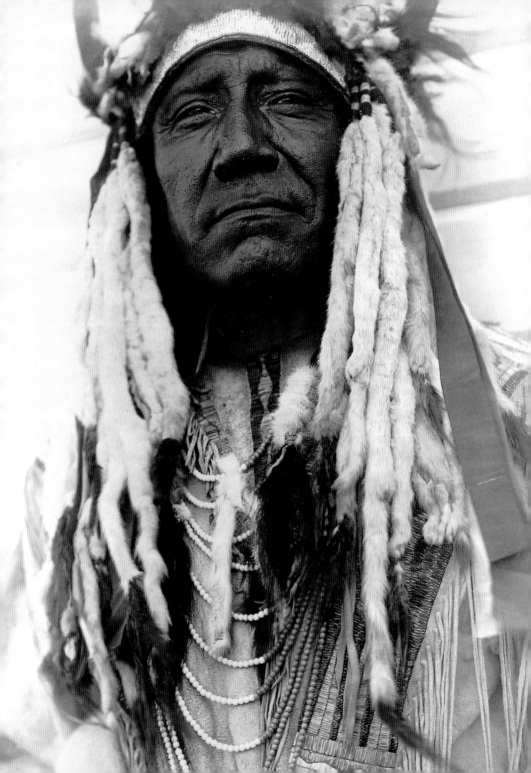

I am going to venture that the man who sat on the ground in his tipi meditating on life and its meaning, accepting the kinship of all creatures, and acknowledging unity with the universe of things was infusing into his being the true essence of civilization.

—LUTHER STANDING BEAR

(1868?-1939) Oglala Sioux chief

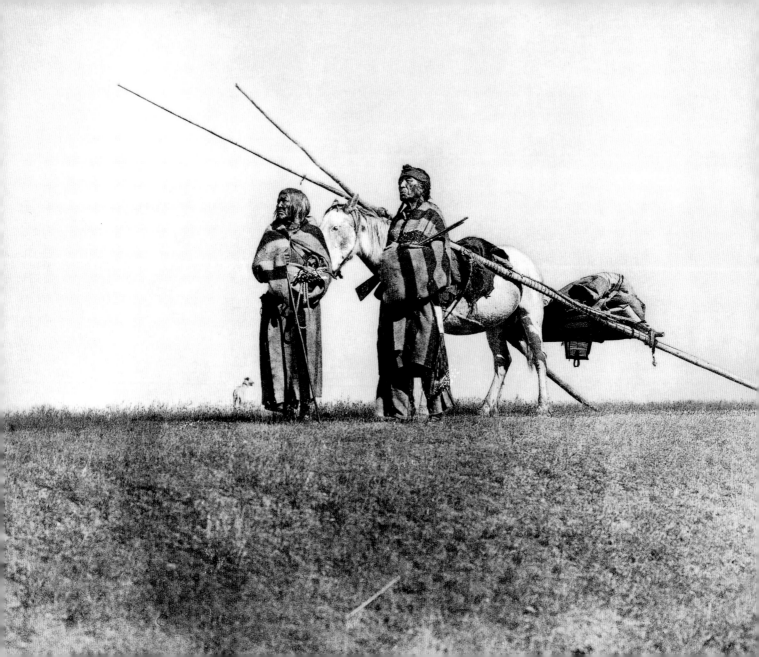

Of all the animals, the horse

IS THE BEST FRIEND OF THE INDIAN,

FOR WITHOUT IT HE COULD NOT GO ON

LONG JOURNEYS. A HORSE IS THE INDIAN'S

MOST VALUABLE PIECE OF PROPERTY.

—BRAVE BUFFALO

(late 19th century) Teton Sioux medicine man

(Pictured Left) A BLACKFOOT TRAVOIS

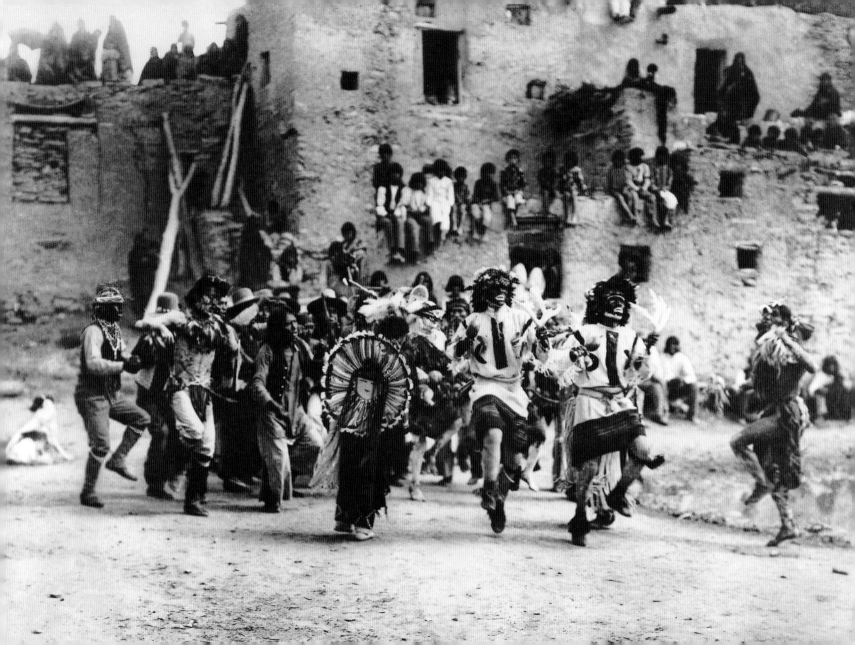

The earth is the mother of all people, and all people should have equal rights upon it. You might as well expect the rivers to run backward as that any man who was born a free man should be contented when penned up and denied liberty to go where he pleases.

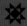

—JOSEPH [HINMATON YALATKIT]
(1830–1904) Nez Percé chief

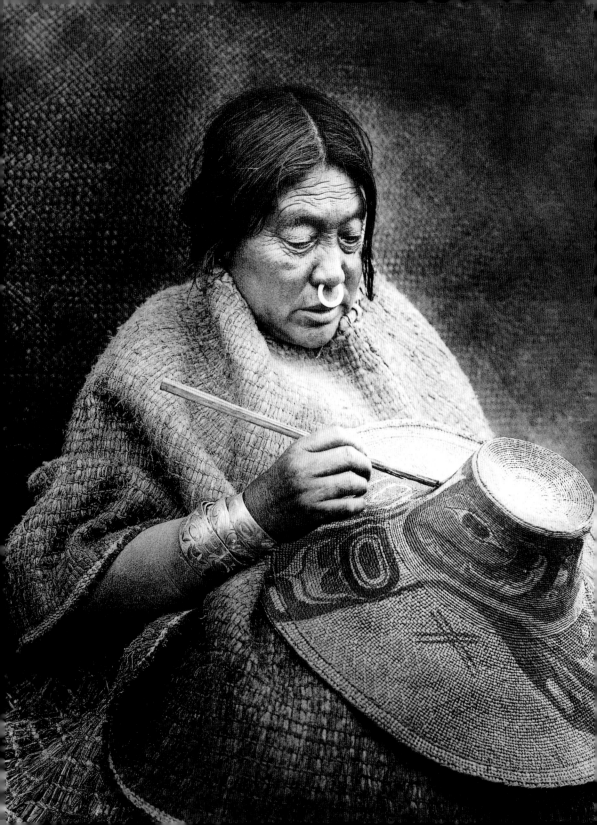

WHEN A MAN DOES A PIECE OF WORK WHICH IS ADMIRED BY ALL WE SAY THAT IT IS WONDERFUL; BUT WHEN WE SEE THE CHANGES OF DAY AND NIGHT, THE SUN, THE MOON, AND THE STARS IN THE SKY, AND THE CHANGING SEASONS UPON THE EARTH, WITH THEIR RIPENING FRUITS, ANYONE MUST REALIZE THAT IT IS THE WORK OF SOMEONE MORE POWERFUL THAN MAN.

—CHASED-BY-BEARS

(1843–1915) Santee-Yanktonai Sioux

(Pictured Left) PAINTING A HAT, NAKOAKTOK

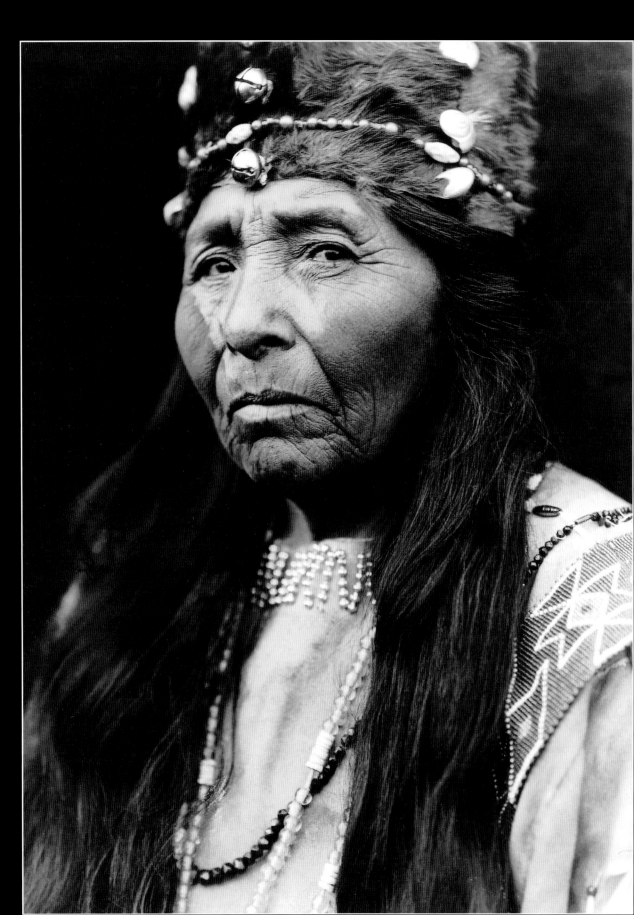

. . . the voice

of the Great Spirit is heard in the
twittering of birds, the rippling of
mighty waters, and the sweet breathing
of flowers. If this is Paganism, then
at present, at least, I am a Pagan.

—GERTRUDE SIMMONS BONNIN [ZITKALA-SA]

(1876–1938) Dakota Sioux

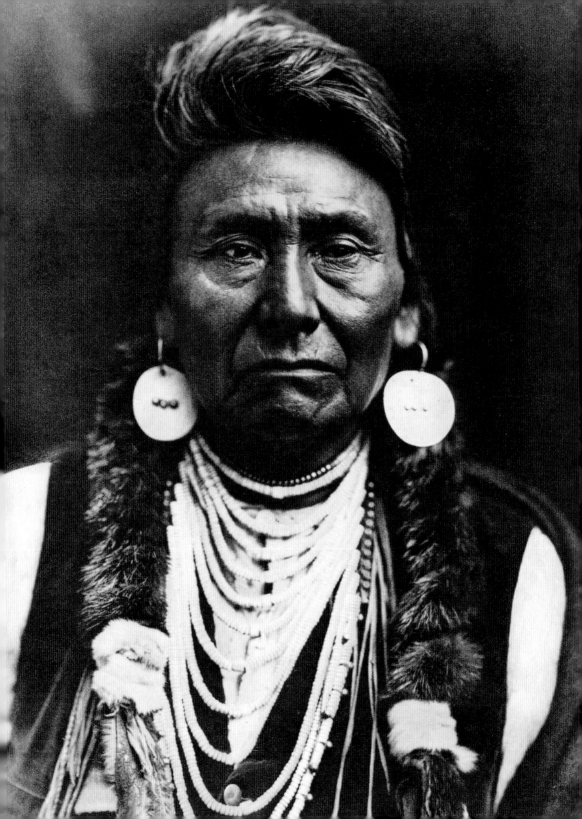

The earth and myself

are of one mind. The measure of the land and the measure

of our bodies are the same. . . .

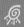

—JOSEPH [HINMATON YALATKIT]

(1830–1904) Nez Percé chief

THE CORN GROWS UP.

THE WATERS OF THE DARK CLOUDS DROP, DROP.

THE RAIN DESCENDS.

THE WATERS FROM THE CORN LEAVES DROP, DROP.

THE RAIN DESCENDS.

THE WATERS FROM THE PLANTS DROP, DROP.

THE CORN GROWS UP.

THE WATERS OF THE DARK MISTS DROP, DROP.

—WASHINGTON MATTHEWS

(19th century) Navajo poet

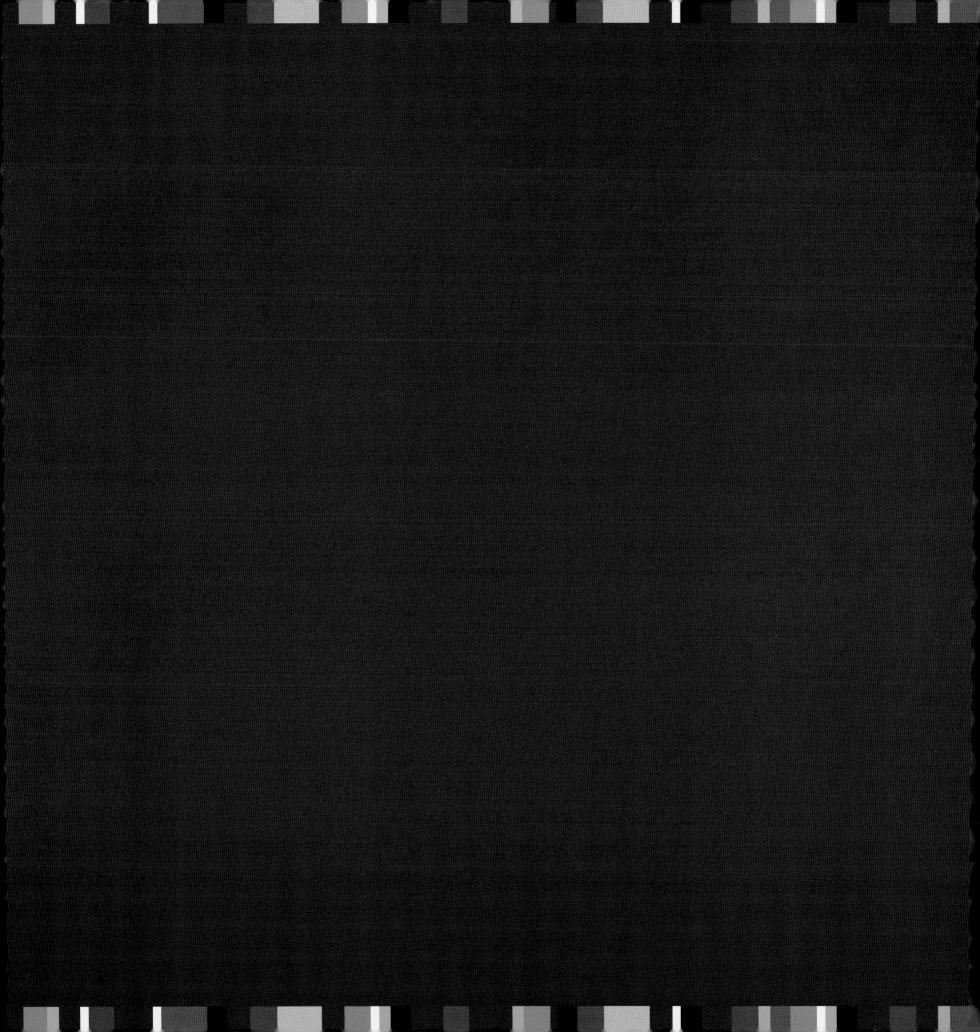

walk the good road

YOUTH, AGE, AND, THE CHANGE OF WORLDS

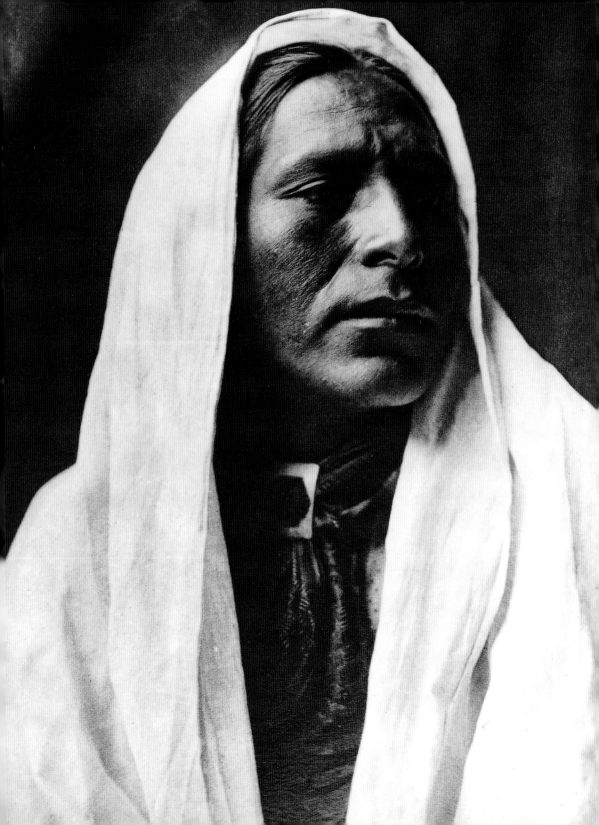

I WAS BORN UPON THE PRAIRIE,

WHERE THE WIND BLEW FREE,

AND THERE WAS NOTHING TO BREAK THE LIGHT OF THE SUN. I WAS BORN WHERE THERE WERE

NO ENCLOSURES, AND WHERE EVERYTHING DREW A FREE BREATH. . . . I KNOW EVERY STREAM AND

EVERY WOOD BETWEEN THE RIO GRANDE AND THE ARKANSAS. I HAVE HUNTED AND LIVED OVER

THAT COUNTRY. I LIVED LIKE MY FATHERS BEFORE ME, AND LIKE THEM, I LIVED HAPPILY.

—TEN BEARS [PARRA-WA-SAMEM]

(late 19th century) Yamparethka Comanche chief

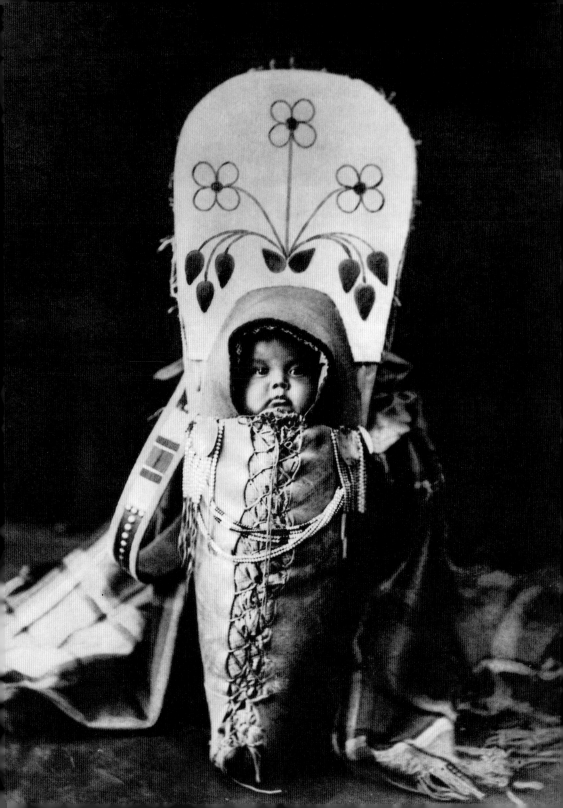

IT IS STRICTLY BELIEVED AND

UNDERSTOOD BY THE SIOUX THAT

a child is the greatest
gift from Wakan Tanka,

IN RESPONSE TO MANY DEVOUT PRAYERS,

SACRIFICES, AND PROMISES.

—ROBERT HIGHEAGLE

(early 20th century) Teton Sioux

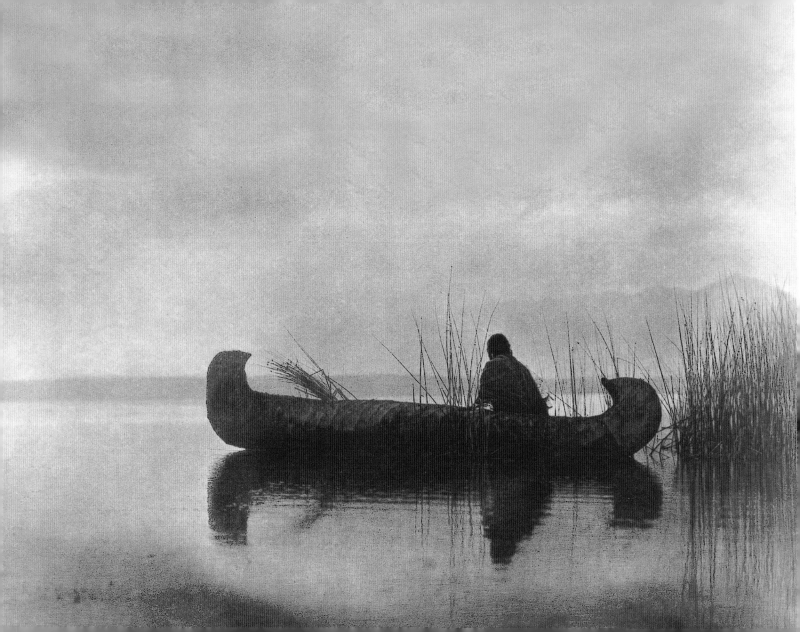

OFTEN IN THE STILLNESS OF THE NIGHT, WHEN ALL

NATURE SEEMS ASLEEP ABOUT ME, THERE COMES A GENTLE RAPPING AT THE DOOR OF MY HEART.

I OPEN IT; AND A VOICE INQUIRES, "POKAGON, WHAT OF YOUR PEOPLE? WHAT WILL THEIR FUTURE

BE?" MY ANSWER IS: "MORTAL MAN HAS NOT THE POWER TO DRAW ASIDE THE VEIL OF UNBORN

TIME TO TELL THE FUTURE OF HIS RACE. THAT GIFT BELONGS OF THE DIVINE ALONE. BUT IT IS

GIVEN TO HIM TO CLOSELY JUDGE THE FUTURE BY THE PRESENT, AND THE PAST."

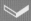

—SIMON POKAGON

(1830–1899) Potawatomie

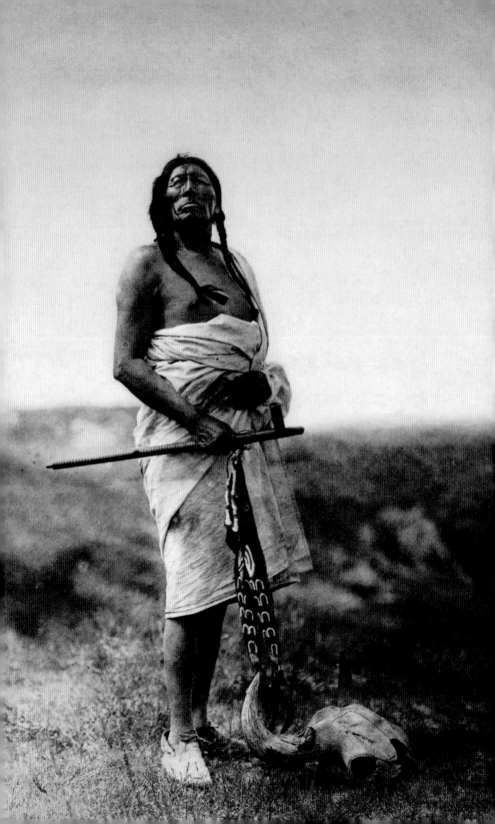

WHEN I WAS A YOUNG MAN I WENT TO A
MEDICINE-MAN

FOR ADVICE CONCERNING MY FUTURE. THE MEDICINE-MAN SAID: "I HAVE NOT MUCH TO TELL YOU EXCEPT TO HELP YOU UNDERSTAND THIS EARTH ON WHICH YOU LIVE. IF A MAN IS TO SUCCEED ON THE HUNT OR THE WARPATH, HE MUST NOT BE GOVERNED BY HIS INCLINATION, BUT BY AN UNDERSTANDING OF THE WAYS OF ANIMALS AND OF HIS NATURAL SURROUNDINGS, GAINED THROUGH CLOSE OBSERVATION. THE EARTH IS LARGE, AND ON IT LIVE MANY ANIMALS. THE EARTH IS UNDER THE PROTECTION OF SOMETHING WHICH AT TIMES BECOMES VISIBLE TO THE EYE."

—LONE MAN [ISNA LA-WICA]
(late 19th century) Teton Sioux

(Pictured Left) SLOW BULL, MEDICINE MAN

IT WAS SUPPOSED THAT LOST SPIRITS WERE ROVING ABOUT EVERYWHERE IN THE INVISIBLE AIR, WAITING FOR CHILDREN TO FIND THEM IF THEY SEARCHED LONG AND PATIENTLY ENOUGH. . . . [THE SPIRIT] SANG ITS SPIRITUAL SONG FOR THE CHILD TO MEMORIZE AND USE WHEN CALLING UPON THE SPIRIT GUARDIAN AS AN ADULT.

—MOURNING DOVE [CHRISTINE QUINTASKET]
(1888–1936) Salish

(Pictured Left) WATCHING THE DANCERS, HOPI

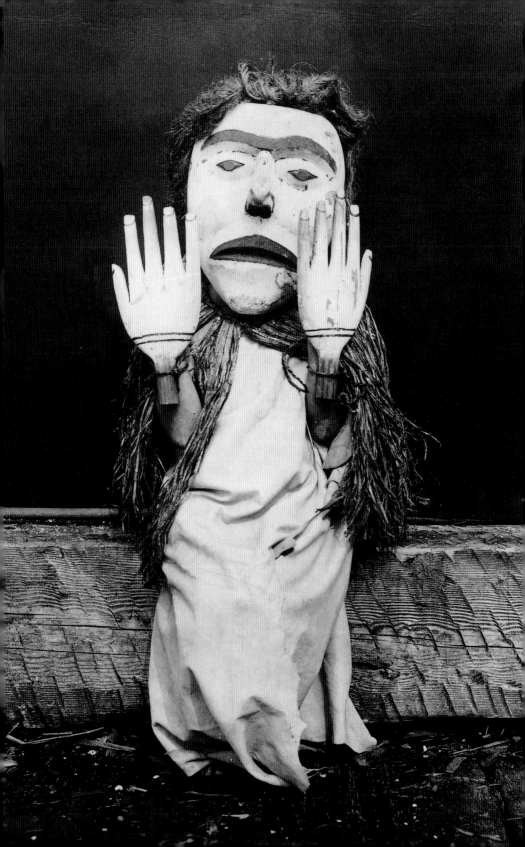

The idea of full dress in preparation for a battle comes not from a belief that it will add to the fighting ability. The preparation is for death, in case that should be the result of the conflict. Every Indian wants to look his best when he goes to meet the great Spirit, so the dressing up is done whether imminent danger is an oncoming battle or a sickness or injury at times of peace.

—WOODEN LEG
(late 19th century) Cheyenne

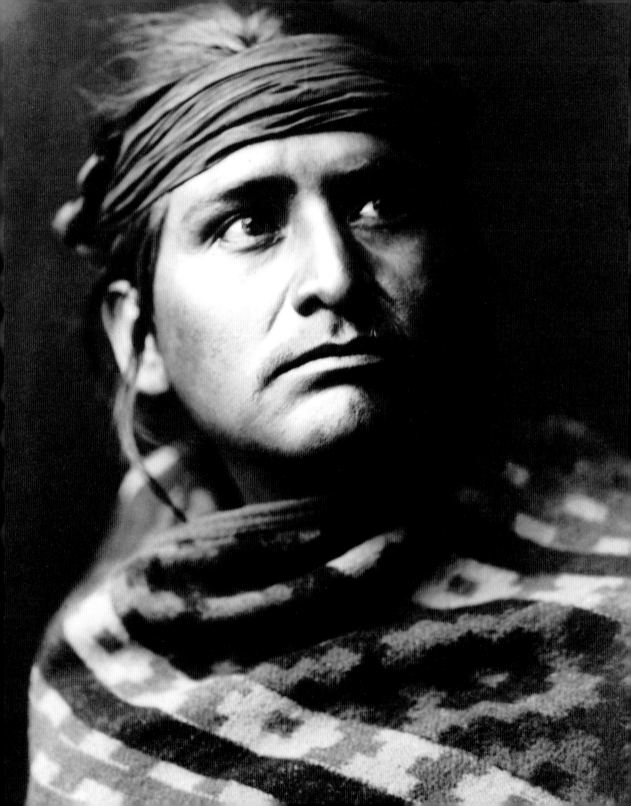

DO YOU KNOW OR CAN YOU BELIEVE THAT SOMETIMES THE IDEA OBTRUDES . . . WHETHER IT HAS

BEEN WELL THAT I HAVE SOUGHT CIVILIZATION WITH ITS BOTHERSOME CONCOMITANTS AND

WHETHER IT WOULD NOT BE BETTER EVEN NOW . . . TO RETURN TO THE DARKNESS AND MOST

SACRED WILDS

(IF ANY SUCH CAN BE FOUND) OF OUR COUNTRY AND THERE TO VEGETATE AND EXPIRE SILENTLY,

HAPPILY AND FORGOTTEN AS DO THE BIRDS OF THE AIR AND THE BEASTS OF THE FIELD. THE

THOUGHT IS A HAPPY ONE BUT PERHAPS IMPRACTICABLE.

—ELY S. PARKER
(1828–1895) Seneca Iroquois sachem,
Brigadier General, U.S. Army

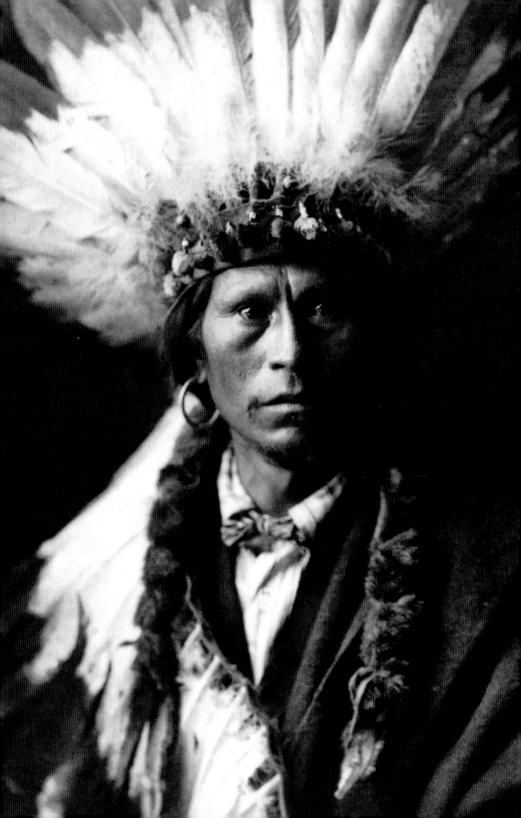

IT IS THE GENERAL BELIEF OF THE INDIANS THAT AFTER A MAN DIES HIS SPIRIT IS SOMEWHERE ON

THE EARTH

OR IN THE SKY, WE DO NOT KNOW EXACTLY WHERE, BUT WE ARE SURE THAT HIS SPIRIT STILL

LIVES. . . . SO IT IS WITH WAKANTANKA. WE BELIEVE THAT HE IS EVERYWHERE, YET HE IS TO US AS

THE SPIRITS OF OUR FRIENDS, WHOSE VOICES WE CAN NOT HEAR.

—CHASED-BY-BEARS

(1843–1915) Santee-Yanktonai Sioux

(Pictured Left) CHIEF GARFIELD, JICARILLA

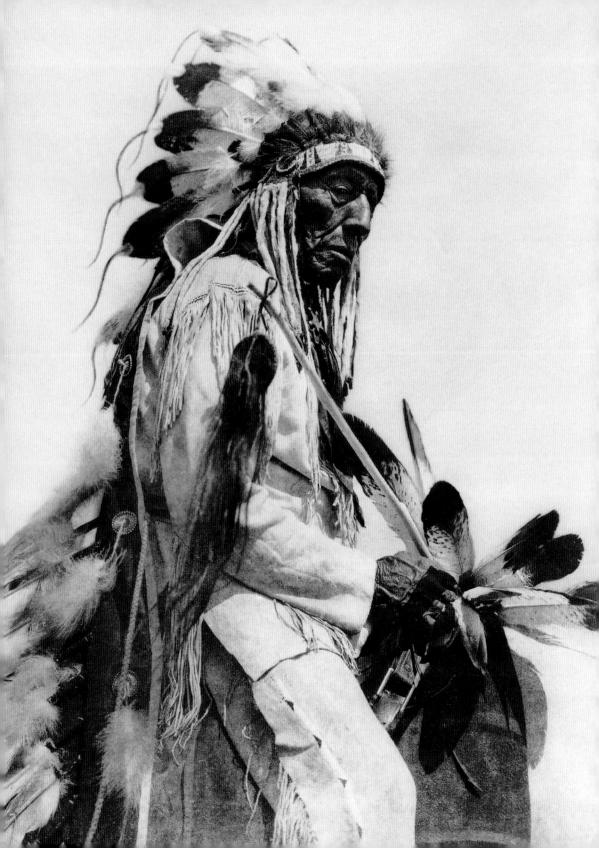

A WARRIOR

WHO HAD MORE THAN HE NEEDED

WOULD MAKE A FEAST. HE WENT AROUND AND INVITED THE OLD AND NEEDY. . . . THE MAN

WHO COULD THANK THE FOOD—SOME WORTHY OLD MEDICINE MAN OR WARRIOR—SAID:

". . . LOOK TO THE OLD, THEY ARE WORTHY OF OLD AGE; THEY HAVE SEEN THEIR DAYS AND

PROVEN THEMSELVES. WITH THE HELP OF THE GREAT SPIRIT, THEY HAVE ATTAINED A RIPE OLD

AGE. AT THIS AGE THE OLD CAN PREDICT OR GIVE KNOWLEDGE OR WISDOM, WHATEVER IT IS;

IT IS SO. AT THE END IS A CANE. YOU AND YOUR FAMILY SHALL GET TO WHERE THE CANE IS."

—BLACK ELK

(1863–1950) Oglala Sioux holy man

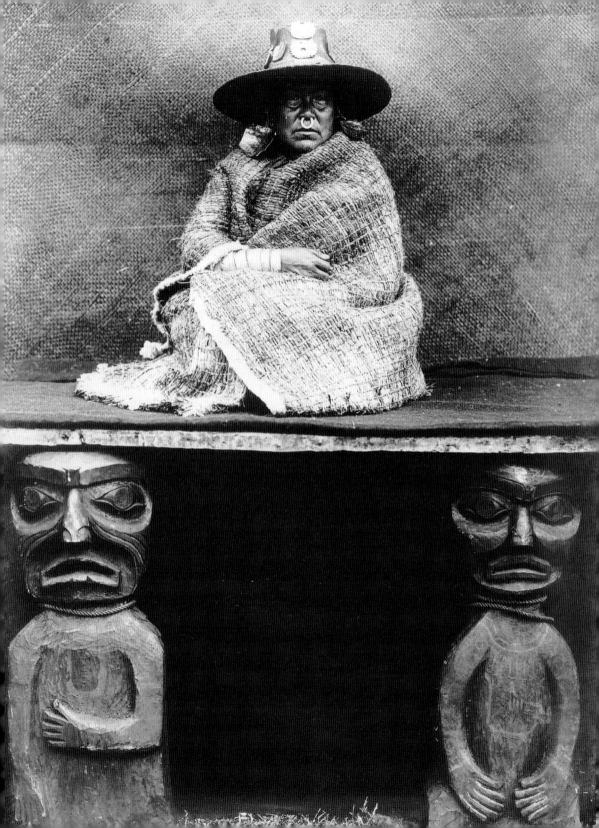

When I am

too old and feeble to follow my sheep

or cultivate my corn, I plan to sit in the house,

carve Katcina dolls, and tell my nephews

and nieces the story of my life.

—DON TALAYESVA

(late 19th century) Hopi Sun Clan chief

(Pictured Left) A NAKOAKTOK CHIEF'S DAUGHTER

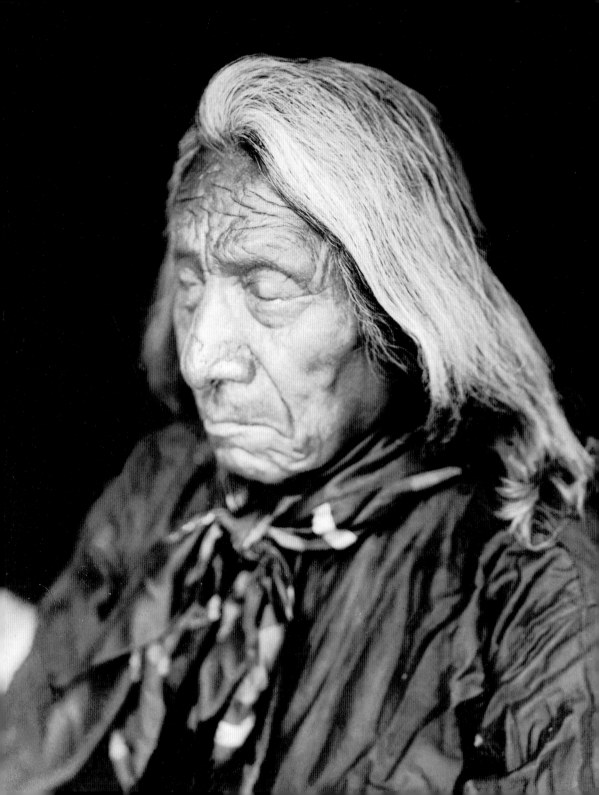

There is no death.

Only a change of worlds.

—SEATTLE [SEATLH]

(1786–1866) Suquamish chief

GLOSSARY

Chief: An elected political official who exercises power over matters of tribal government and justice, and helps carry out his people's wishes.

Holy man or **medicine man:** A tribe's physician and priest. The medicine man used medicinal plants and religious ceremonies to cure illnesses. He was believed to have supernatural abilities of communication with spirits.

Paho: A painted and carved "prayer stick," approximately six inches long. Attached to a bag of sacred corn meal, it was used by the Hopi Indians in ceremonies to appease their gods.

Sachem: Among the Massachusetts Indians, the supreme ruler of a specific territory.

Tirawa: The Pawnee tribe's "father" spirit. The tribe believes his messengers include the wind, thunder, lightning, and rain.

Wakantanka, Wakan Tanka, or **Wakan-Tanka:** The "great spirit" of the Dakota Indian tribe.